The Complete Guide to
DRAWING
for Beginners

21 STEP-BY-STEP LESSONS

YOSHIKO OGURA

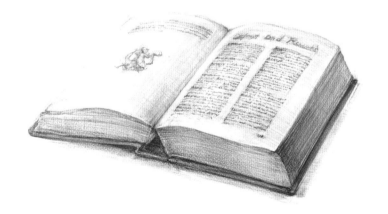

TUTTLE Publishing

Tokyo | Rutland, Vermont | Singapore

Contents

Part 1 The Basics

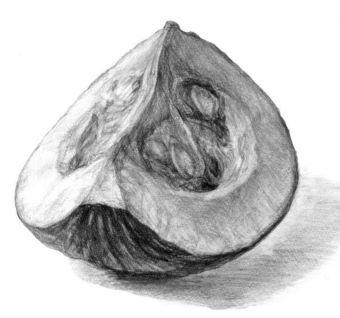

Part 2 Drawing Lessons

Basic steps 40

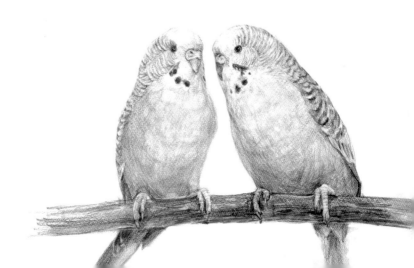

Quick Lookup Index

Here is a list of the objects introduced in this book.

Simple Shapes

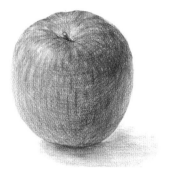

Apple page 42

Milk Carton page 46

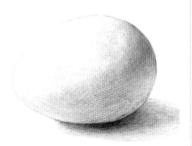

Egg page 50

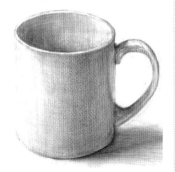

Mug page 52

Hard and Soft Surfaces

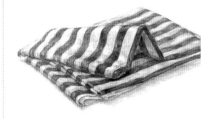

Blanket page 58

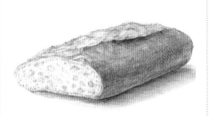

French Bread page 60

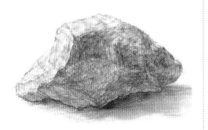

Rock page 62

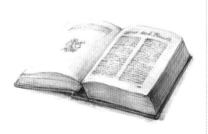

Open Book page 64

Transparent Objects

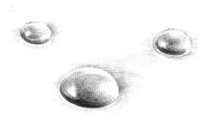

Water Droplets page 68

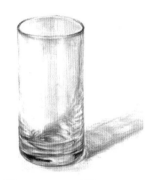

Glass page 70

Complex Shapes

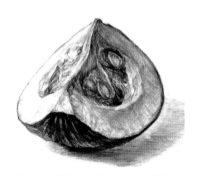

Piece of Squash page 76

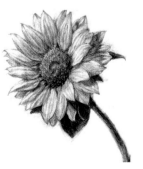

Sunflower page 78

Human Anatomical Features

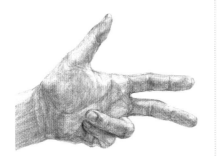

Hand page 84

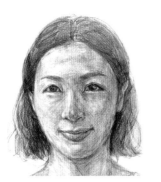

Face page 86

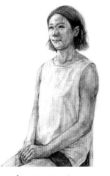

Upper Body Portrait page 90

Landscape Elements

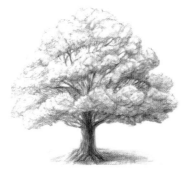

Tree page 98

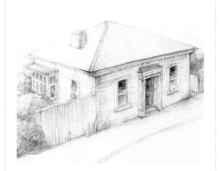

Building page 100

Animals

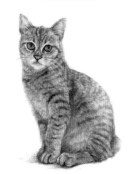

Cat page 106

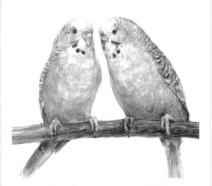

Parakeets page 110

Combining Objects

Color Contrast page 116

Different Textures page 118

How to Use This Book

Keep the following points in mind in order to take full advantage of the lessons in this book and enjoy the learning process.

Practice with objects that are handy

To practice the basics, you can take advantage of things that are close to you, such as apples or eggs. The simple things around you will help you get a lot of practice. These are things you can draw any time, and just draw casually. The objects covered in this book are categorized on pages 4–5. Use the Quick Lookup Index there to choose subjects to draw.

Refer to the photographic and finished sketch examples

It's challenging to render full-color objects monochromatically. In these lessons, refer to both the color photograph of the subject and the finished drawing to refine your shading technique.

Lesson **1**

Apple

An apple is a simple familiar object. Select the most well-formed, dent-free apple that you can.

Photo example

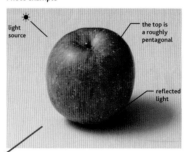

light source

the top is a roughly pentagonal

reflected light

Basics to apply (pages 26–35)

POSITION | SHAPE

LIGHTING | TEXTURE

Your composition should be slightly larger than actual size. That way it will be easier to work on. Place the apple slightly to the left of center on your paper to leave room for the shadow. Because the red of the apple is quite saturated, the whole image will come out relatively dark, so plan on significant shading. You may think of apples as being roughly spherical, but the top part is actually defined by a roughly pentagonal shape. You can use straight lines first, and then blend the shapes together (page 38).

Completed drawing

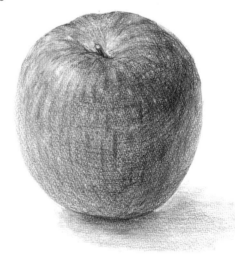

The basics

The foundational skills are divided into five sections in the first part of this book. The appropriate techniques needed to draw each subject are explained on pages 26–35. All these skills can be put into practice as you progress through this book.

Process explanations

The step-by-step process of drawing each subject is explained through a series of photos. There will be many pointers along the way to guide you through.

SHAPE

1
Sketch in some guide lines. Check the proportions, and measure the length and width. Use a B pencil during this process.

TIP Anchor your drawing's position on the page by working from bottom up.

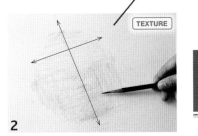

TEXTURE

2
With broad strokes, shade in the length and width. The "red" parts will become considerably dark, so begin roughing in the shading now.

PART 2

Drawing Lessons

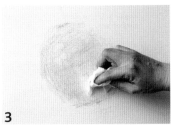

3
Blend the light shading with a tissue (page 22).

TIP You can also just use your fingers.

4
Instead of drawing in the shadow separately, add those shades as you go in horizontal strokes.

TIP Think of the shadow as part of the object.

Useful terminology

Technical terms are easy to understand with the right explanation. I decided to keep the explanations plain and simple in this book to make it easier for beginners.

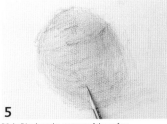

5
"Color" in along the contours of the surface.

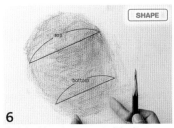

SHAPE

top

bottom

6
Check the wider and narrower parts of the object.

TIP Keep in mind that while the apple is basically round, the top of the apple is actually a pentagon.

Drawing Simple Shapes *43*

Refer to the sample illustrations along the way

For many basic concepts, it is often better to show than tell. This book includes a lot of illustrations to help you understand what is meant to be done. The illustrations will help you remember the basics.

Use the side of the pencil for broad strokes.

Terms Used in Drawing

Axis A line passing through the center of a solid object. In objects such as fruits and vegetables, the axis runs through the core.

Backlight Light shining from behind the subject.

Base drawing The first layer of rough shading that enables you to define the general shape and tonal variations before you begin to refine the drawing.

Brightness The degree to which light reflects from an object's surface.

Centerline A line that bisects a symmetrical object being depicted. Alternatively, a line that divides the horizontal or vertical halves of a composition.

Center point A point positioned in the center of the object being depicted. Alternatively, a point in the middle of the various elements of a composition.

Composing The act of mindfully positioning and scaling an object or objects on the drawing surface. See page 26.

Composition mark A lightly drawn mark to serve as a guide for determining the position of an object at its base, used before roughing in the preliminary sketch.

Contrast The observable difference in adjacent light and dark areas of a drawing. Areas of high contrast exhibit an intensity that draws the eye.

Depth The distance from the front to the back of the object. Depth in drawings is often expressed by subtly blurring and lightening the portions that should appear farthest from the viewer.

Details Final, small, carefully made additions to a drawing that make it come alive with realism.

Diagonal A line connecting the vertices of two non-adjacent corners of a polygon. Also, for polyhedra, a line segment connecting two vertices that are not on the same plane.

Dominant Eye The eye that is used primarily for sight. The non-dominant eye plays a supporting role in correcting focus and comprehending depth perception. To determine your dominant eye, hold an index finger out while you focus on a distant object. Move your finger to cover the distant object, and then close one eye at a time. The eye that still sees the distant object as being covered up is the dominant one.

Eye level The vantage point of the viewer. When discussing perspective, it refers to the level of the vanishing point. See page 56.

Focus In drawing, it is the part of the image in the foreground that commands attention and draws the eye.

Form The shape of an object or group of assembled objects. See page 30.

Free-hand Drawing without the use of tools such as a ruler or French curve. This book focuses on freehand drawing instruction.

Golden ratio A ratio expressed as 1:1.618 in geometry, which is the basis of the "golden rectangle," an aesthetically pleasing shape that has been used in many famous artworks, such as Leonardo da Vinci's "Mona Lisa."

Gradation Gradual changes from one shade, color or texture to another.

Highlight The location or locations on an object where the most light is reflected to the viewer's eye. If the object is polished, the highlight will be sharply defined. If the object is textured, the highlight will be diffuse.

Inherent color The actual color of the surface of a given object, unrelated to the intensity of the lighting.

Intersection The vertex where the edge of two planes of a three-dimensional shape meet. Understanding of planes and vertices is the basis of drawing. See page 38.

Light source The natural or artificial point or points from which light is directed toward an object. In drawing, it is important to determine the light source, and understand how it affects shading, highlights and shadows. See page 8.

Low Angle Observing the object to be drawn from a low vantage point.

Masking tape Low-tack painter's tape useful for recording the position of an object that is likely to be moved before the drawing is completed.

Mass A sense of volume and weight achieved through careful attention given to emulating an object's observable characteristics.

Measuring stick Any thin rod used to visually measuring an object. Most artists use their handy pencil to measure. See page 30.

Natural light Light from the sun.

Object The subject of your drawing.

Outline A line that represents the border between objects and space. Outlines in the foreground tend to be heavier and sharper, while outlines in the background tend to be lighter and fuzzier.

Pencil pressure The pressure applied to the tip of a pencil when drawing. A wide range of expression can be realized by varying the pressure as you draw.

Perspective A method of visually expressing a three-dimensional space on a two-dimensional plane, thereby creating the illusion of depth. Generally, one-point perspective (page 57) is the most familiar. It is used to illustrate the implied distance from an object's front to its back. One-point perspective, two-point perspective and three-point perspective respectively increase the sophistication and realism of drawings. Perspective is widely used not only in drawing but also in various other fields of visual expression (construction, animation, cartooning, illustration, etc.).

> **One-point perspective** A technique for depicting depth where lines converge toward a single vanishing point. See page 57.

> **Two-point perspective** A technique for depicting depth where lines converge toward two vanishing points. See page 57.

> **Three-point perspective** A technique for depicting depth where lines converge toward three vanishing points. See page 57.

Plaster statue A three-dimensional plaster model. Because the model is completely white with easy to understand contours, it is often used as an object for drawing studies. Classical Greek and Renaissance sculptures are typically used as prototypes.

Reflected light Diffuse light that has been bounced back from the surface or surfaces closest to the object. By depicting reflected light, you can impart a realistic three-dimensional effect to the subject. See page 28.

Saturation The degree of color depth. Vivid colors exhibit high saturation, and faded colors exhibit low saturation.

Shade The darker area on an object when light from the light source has been blocked by something (including parts of the object itself). See page 28.

Shadow Shadows are cast on the side of an object opposite to the light source. See page 28.

Shaping Roughing in the shape and shades of the object at the outset of a drawing project.

Skeletal Structure The underlying structure of vertebrates, comprised of the jointed bones and cartilage. Drawing accurate human or animal forms is much easier if you are able to envision the skeleton as you draw.

Sketching The act of drawing quickly, primarily with simple lines and no shading, capturing the features and poses of subjects such as people and animals. Also called *Croquis* (pronounced "croaky") drawing. See page 114.

Sketch lines Light lines quickly put down when roughing in a shape. They help the artist gradually ascertain where the edges of the object being drawn should appear in the finished drawing.

Space In the real world, a three-dimensional expanse that we all inhabit. In drawing, techniques must be used to emulate the look of three-dimensional space, such as using contrasting bold and thin lines, dark and light tones, and sharp and fuzzy details. See page.35.

Structure The individual underlying shapes that together form the overall shape of an object. For drawing people and animals, it is important to understand how the skeleton and muscles fit together to affect the balance and form of the subject.

Surface The visible part of the object you are drawing. The surface is gradually roughed in and refined with shading, highlights, shadows, textures and other details to present a realistic representation of the physical object being drawn. See page 38.

Texture The visual representation of the tactile feel of the real-world subject through the skillful application of pencils and the kneaded eraser. See page 34.

Three-dimensional effect The illusion of depth created through the use of perspective, shading, and using bold, dark, sharp lines on parts of the drawing that are to appear closer to the viewer and thin, light, fuzzy lines on parts of the drawing that are to appear farther from the viewer.

Tone The color of the surface of an object. The play of light and shadows across the surface of the object being drawn is emulated through the use of gradation, with shades of gray mimicking the color saturation of the subject.

Vanishing point A point on the horizon of a drawing to which receding parallel lines converge. See page 56.

Let's Start Drawing!

At first, drawing might seem like a trivial pastime, but learning to draw well can greatly enrich your life. Enjoyable in and of itself, drawing is also an important stepping stone to other related skills. It hones your hand-eye coordination, increases your understanding of how balance and good composition appeal to the eye, and sharpens your perception of the things around you and how they relate to each other.

Your drawings don't have to be extravagant to be beautiful or interesting. Drawing is simply a way to artfully capture a scene or subject, or even express what's in your mind's eye. You can use your imagination to put unseen worlds on paper using this valuable skill.

Every part of the act of drawing can be meaningful. For example, it's therapeutic to pare back the wood of a dull pencil as you reveal a fresh, sharp point. When I analyze an object I'm about to draw, I hold my breath for a brief few seconds, so I can keep still. In that moment, I can feel my mind become clear and calm. When drawing a long line, I move my shoulders as if I'm working out. And when I'm controlling the intensity of a line, it's as if I'm playing an instrument.

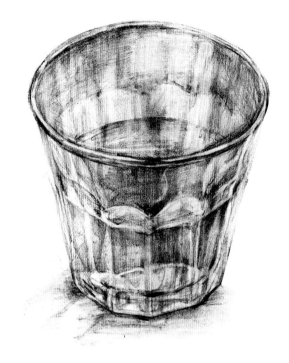

With your drawing skills, you can record the things you've seen. The difference between drawing and simply taking a picture is that you can determine a given memory in a unique way. There are intangible benefits you can receive from the object you have studied and drawn in detail. Drawing is primarily a black and white endeavor, but you can see the colors in your mind while you are drawing.

Don't lose confidence before even starting. There isn't anything that can't be improved by practicing. It would be a missed opportunity if we could somehow accelerate the process of improvement. The struggle of learning is part of the journey of realizing your artistic skill. I hope this book helps you on your way to becoming a drawing expert.

—Yoshiko Ogura

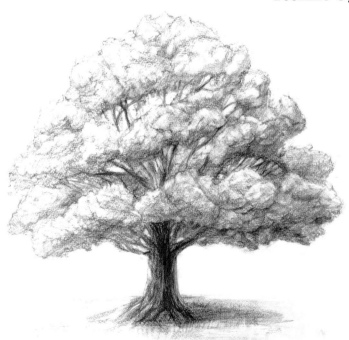

Gathering Your Tools

a. Pencils

Uni/Hi-Uni, Staedtler and Faber-Castell are the three pencils I choose to use for drawing. Each has its own quirks, and the feel of each differs slightly. Try using different kinds of pencils to find which ones work best for you.

Uni/Hi-Uni

The Uni pencil made by Mitsubishi, and thus it is a product of Japan. The lead is on the softer side, and the color is a brownish black. This type of pencil can be good for drawing portraits and natural scenery. Hi-Uni makes a bluish black mark, and the lead is on the harder side. The leads of these pencils are dense, and the barrel is made of a good quality wood.

Staedtler

Staedtler pencils are manufactured in Germany. This type of pencil seems to be best suited for drawing architectural features or mechanical objects. The color given by this pencil is a bluish black. The lead is harder than the Uni pencils.

Faber-Castell

Another pencil from Germany, the lead is quite hard, so it is suitable for someone who presses firmly when drawing. It takes experience to use this pencil effectively.

> **TIP · The Darkness and Hardness of the Pencil**
>
> There are different levels of hardness of pencils from 10H–10B. 10H has the lightest shade of lead. You might ask, "There are this many shades of lead?!" The world of drawing isn't just black and white. There are many shades and weights of lines to express texture and color. At first, you might feel a little lost about which to use, but for starters I recommend 3H–4B. You can widen your spectrum of shades as you gain experience.
>
> Hard (Light)
> Medium
> Soft (Dark)
>
> 10H
> ⋮
> 3H
> 2H
> H
> F
> HB
> B
> 2B
> 3B
> 4B
> ⋮
> 10B
>
> Recommended range

b. Kneaded Erasers and Plastic Erasers

A kneaded eraser is not a solid eraser, but resembles clay. It doesn't wear away and doesn't leave behind eraser residue. This is an important tool for drawing. There are many brands of kneaded erasers, though the quality doesn't differ greatly. There's soft, normal and hard types. It is best to choose soft. Kneaded erasers will enable you to erase fine details. Plastic erasers have sharp corners that you can use to make precise erasures.

c. Craft Knives

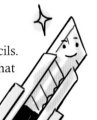

The blade is used to sharpen your pencils. Keep the blade in sharp condition so that the lead and wood can be safely and effectively sharpened.

d. Drawing Board

A drawing board provides a rigid backing for your paper, and keeps it in place. It makes for a convenient way to carry your drawings around. Some people use wood panels or clipboards.

e. Drawing Paper

Select paper that has some heft and has a slight roughness (or "tooth") to its surface. Avoid using paper with a heavily textured surface, like that used for watercolor—the pencil will snag in the bumpy parts as you draw. On the other hand, if you use a glossy surface such as vellum, the lines may smudge. That being said, once you become accustomed to drawing on a smoother surface, you will be able to manage the smudging issue.

Drawing paper — Easy to draw / OK

Watercolor paper — Too bumpy / NO

Vellum — Smudgy! / NO

f. Binder Clip/Push Pin

The clips are for holding papers to the drawing board, and keeping the paper in place. A big solid clip can be versatile and come in handy for many things. A push pin could also do the trick, if you don't mind leaving holes in the paper.

g. Fixative Spray

This transparent spray lightly coats your drawings and keeps them from smudging and cleanly preserve your works. It is discouraging to see your hard work smudge away and become ruined. After completing a great masterpiece, be sure to spray on your fixative spray!

Useful Items to Have on Hand

Tissues, blending stumps or spare cloths

These items are useful for smudging parts of your drawing. You can also just use your fingers—if you don't mind getting them dirty.

Use something like gauze that does not damage paper

Viewfinder (page 36)

You shouldn't rely heavily on this grid to scale your drawings, but it comes in handy on occasion.

Easel

If you have a desk, this item isn't a necessity. However, when working on large pieces or drawing outdoors, an easel becomes an essential item. There are foldable and portable types you can select from.

For indoor use

For outdoor use

Getting Ready to Draw
Organize your tools before you start!

As with beginning any athletic activity, you need to warm up and get ready before drawing. It is important to get everything ready to use to reduce distractions while you are drawing. Here are some tips to help you prepare.

Sharpening your pencil

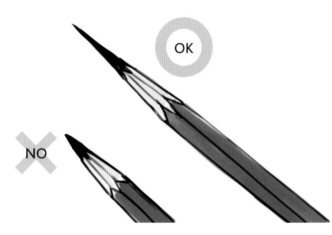

OK

NO

Use a craft knife to sharpen your pencil

Use a craft knife to sharpen your pencil by hand—don't use a pencil sharpener for this task. The point of the pencil should be trimmed to be longer than it would be if it was being used for writing. This allows you to produce a finer line. It also makes the side of the lead available for shading. The only way to achieve this is to sharpen the pencil by hand. You can also sand the point into shape using a fine grade of sandpaper.

1

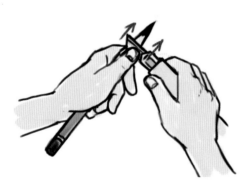

When sharpening your pencil, hold it in your left hand, and hold the razor in your right hand. Support the blade by pressing on it with the thumb of your left hand while you whittle away from you with your right hand. (If you're left handed, reverse the hands described in the procedure above.)

2

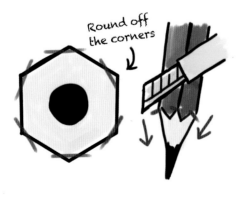

Round off the corners

Rotate the pencil with your left hand. Shave away at the material, and try to keep the shape of the point acutely conical. Pare away both the lead and the wood as you go.

> **TIP** **Tips on sharpening the pencil**
>
> If you are too aggressive when sharpening, the shape of the pencil will be negatively affected, and the wood portion will become asymmetrical. You might even scratch the paper when drawing because of the uneven angles of your pencil. When you sharpen the pencil well, it will be easy to use. Put effort into sharpening your pencils well.
>
>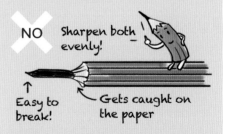
>
> NO Sharpen both evenly!
>
> ↑ Easy to break! Gets caught on the paper
>
> If there's too much unsupported lead sticking out, it will easily snap. If there's too much wood and not enough lead, you might scratch the paper, so give plenty of attention to the tip of your pencil.

Preparing a kneaded eraser

A kneaded eraser is a "white pencil"

The kneaded eraser is flexible and can be molded into any shape you like. It is a given that its job is to erase, but it also plays an additive role. You draw and erase constantly as you work on a drawing. Quite often you are using the eraser to create and add detail. Hence, it can be considered a "white pencil."

Cut the eraser

When you take your kneaded eraser out of the package, cut it into the right size for you. As you can see in the image below, the eraser is just the right size to be held with ease. If the eraser is too small, the eraser will deform as you use it, or smear on the paper. Have your erasers prepared in advance and ready to use in order to reduce distractions while you're drawing.

Knead the eraser

To prepare your eraser for use, hold it in your hand to warm it up and massage the eraser into a shape that is easy for you to hold.

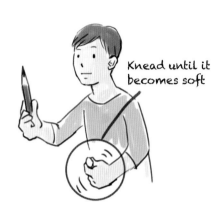

Knead until it becomes soft

Have it in an easy-to-hold shape

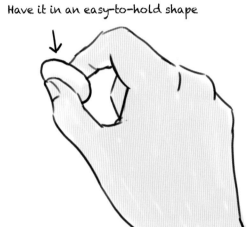

Checking the paper surface

Identifying the front and back

The paper you use should have distinct front and back surfaces. There's the rougher side, and the smoother side. The smooth side is the front, and the rough side is the back. It might be hard to discern at first, so you might want to ask someone else for their opinion.

Front
Smooth to the touch

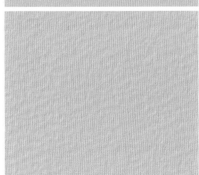

Back
Rough to the touch

Paper surfaces

Let's touch both sides

Back

Front

Having good posture

Keep to one vantage point

It is important to keep your vantage point consistent. Once you choose to draw at a certain angle, stick to that angle and view position. If you keep changing positions, you will lose the perspective you were using.

When using an easel

Set the object at a 45 degree angle to the easel. Set the object in front of you, where you can easily view it. It is also important to set the object on the proper side. If you place the object on the same side that you hold your pencil, your viewpoint may shift. Be mindful of where you place the object.

> **TIP** Drawing incorporates your hands, eyes and brain. It is quite work, so take 10 minute breaks every hour. Taking proper breaks is the shortcut to improvement.

When drawing objects on the table

Sit squarely in your chair and keep your back straight. Keep your face at a right angle to the paper—refer to image below.

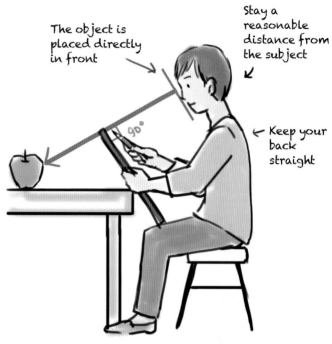

The object is placed directly in front

Stay a reasonable distance from the subject

90°

← Keep your back straight

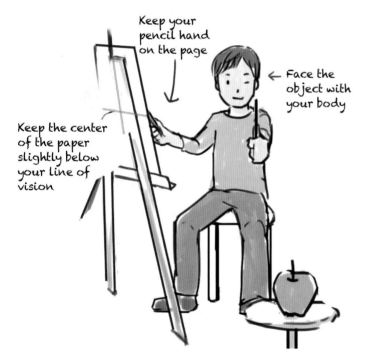

Keep your pencil hand on the page

← Face the object with your body

Keep the center of the paper slightly below your line of vision

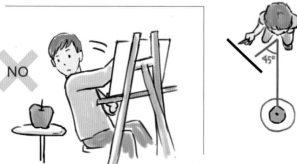

NO

45°

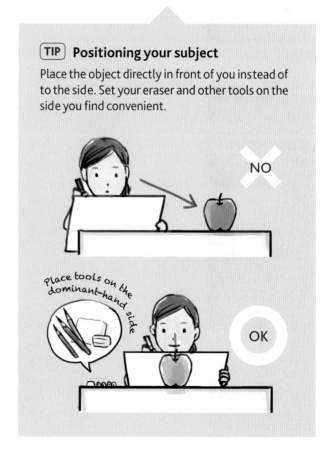

> **TIP** Positioning your subject
>
> Place the object directly in front of you instead of to the side. Set your eraser and other tools on the side you find convenient.

NO

Place tools on the dominant-hand side

OK

Part 1

The Basics

Master this collection of fundamental skills
before proceeding to the lessons.

Getting to Know Your Tools

You wouldn't call someone you just met a "close friend" until you got to know them well. It's no different with your drawing tools. Get to know how your tools can serve you. The better you know them, the more you can use them to their full potential. This is one step to improving your skills.

How to hold the pencil

The basic way to hold the pencil

Don't grip on the pencil too firmly, and relax your hand. Use your thumb, index finger and middle finger to hold the pencil. This way allows you to move the pencil in broad motions.

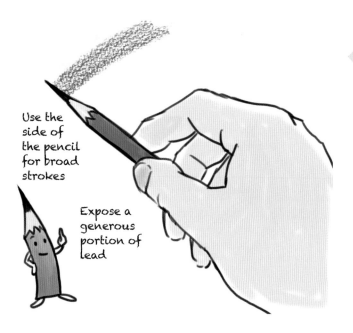

Use the side of the pencil for broad strokes

Expose a generous portion of lead

TIP Move your arm and shoulder

In order to draw long lines easily, you must move your entire arm. It is important to also move your wrist. Just like when playing ping-pong, you move your entire arm for a stroke.

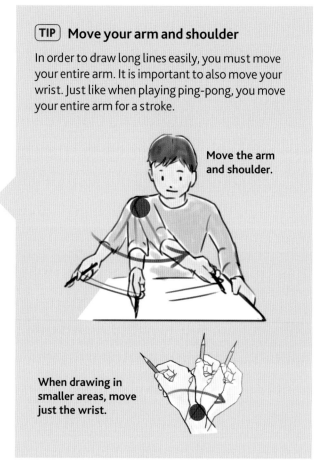

Move the arm and shoulder.

When drawing in smaller areas, move just the wrist.

Holding the pencil when drawing details

When you are trying to draw with bolder lines, or adding fine details, hold the pencil as you would to write. Adjust your grip as needed.

Hand, eye and pencil coordination

This exercise will help you explore making different strokes. Practice on a large sheet of paper and use a 2B pencil.

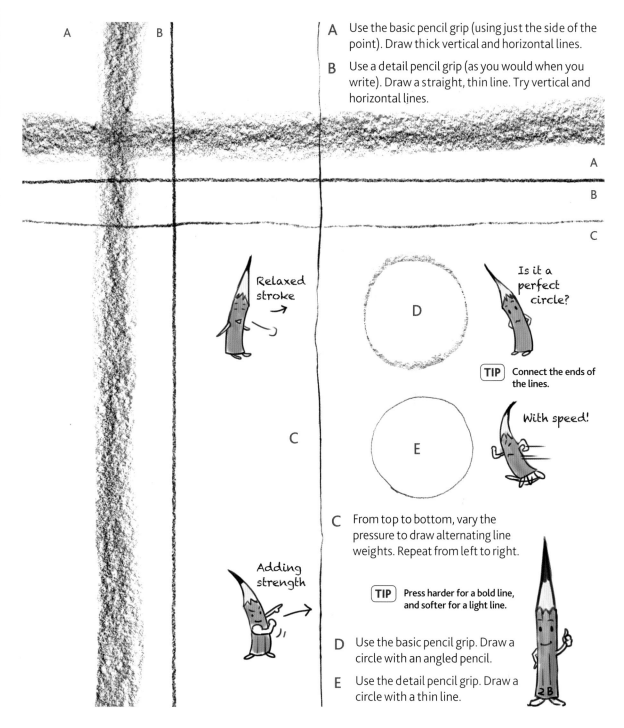

A Use the basic pencil grip (using just the side of the point). Draw thick vertical and horizontal lines.

B Use a detail pencil grip (as you would when you write). Draw a straight, thin line. Try vertical and horizontal lines.

Relaxed stroke →

Is it a perfect circle?

TIP Connect the ends of the lines.

With speed!

C From top to bottom, vary the pressure to draw alternating line weights. Repeat from left to right.

TIP Press harder for a bold line, and softer for a light line.

Adding strength →

D Use the basic pencil grip. Draw a circle with an angled pencil.

E Use the detail pencil grip. Draw a circle with a thin line.

These exercises will take you a long way toward building your basic drawing skills. Also try making fast and slow strokes. It will take some practice before you can draw a good straight line and a perfect circle. Your papers might become full of lines and circles, but practice makes perfect! Master your hand, eye and pencil coordination.

Gradation palettes

Practice creating different shades

There are of course many more tones between solid black and stark white to express, so you must master making different shades. By making a gradation palette, you can understand how to make the variations of shades possible with your pencil. Make seven 2 x 2 cm boxes, and fill in them with different shades of black.

2B pencil
The lead is soft, so be careful not to start out too dark.

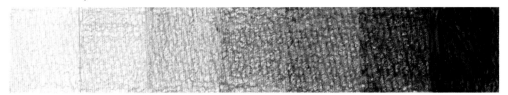

H Pencil
This time the lead is hard, so it takes more effot to achieve darker shades.

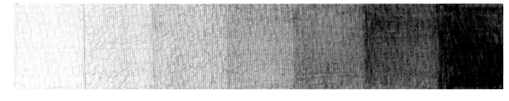

Variety of Pencils
For the darker shades use B pencils, and for the lighter shades use H pencils.

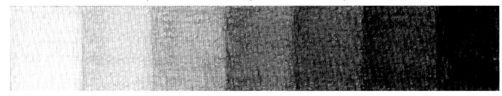

(TIP) **Put some intervals in between**

Once you finish one palette, let some time pass before you try another one. Compare each of your palettes to see how they vary. Evaluate the consistency and depth of your gradations.

Gradation Practice

Here are boxes for you to practice with.
You can make copies of this page to use multiple times.

Try 10-step palettes too!

Expressing color with the pencil

The color tone depends on the shading

Color tone is expressed through saturation. You might wonder if it is possible to emulate color tones with just a pencil. Here are some ways to express color saturation using monochromatic by pencil shades.

Full saturation Less saturation

Try shading with B pencils

Try shading in a small area with your B pencil. Do it with an angled basic grip. Then, make an identical shaded patch to one side, and smudge the second patch with a tissue or your fingers. You may notice the blended area appears to be a darker shade than the unblended one. The blended area has more coverage in the pores of the paper, so it appears darker.

Not blended

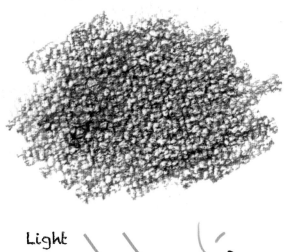

Blended in

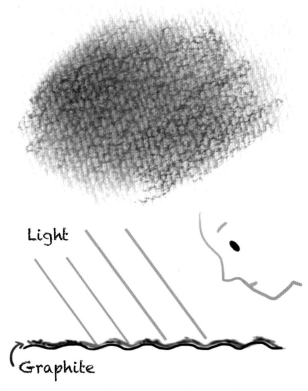

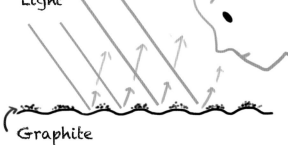

Light

Graphite

The white pores of the paper appears as reflection to the eye.

Light

Graphite

The pores are colored in black, so it reflects less light.

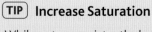

TIP Increase Saturation

While not as consistently dark as the blended patch (above right), the unblended shade on the left expresses more saturation in color. Now you can play around with different "colors" as you practice expressing color tones with your pencil.

Saturation up

Saturation down

Work with the kneaded eraser

Widen your color expression with the eraser

If you've kneaded your eraser a bit to warm it up, it should be soft and ready to use at this point. The kneaded eraser is just as important a tool as your pencil. Mastery of using this tool will widen your repertoire of color expression techniques. Here are some tips.

Use a long and slender shape

As shown in the picture to the right, make your eraser rounded with a pointed end. As mentioned previously, think of it as a "white pencil." Drawing the white lines isn't as easy as it sounds. Whether you press lightly or firmly, it will feel awkward at first. It will take some practice to get used to it.

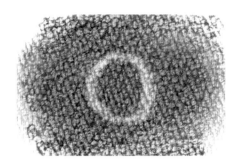

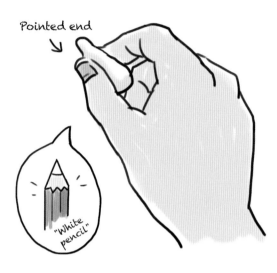

Pointed end

"White pencil"

Use a wide shape

This time, try forming your eraser into a wider shape. It can be used like a paintbrush to erase wider areas. Use the eraser like this to lighten larger areas in your drawing.

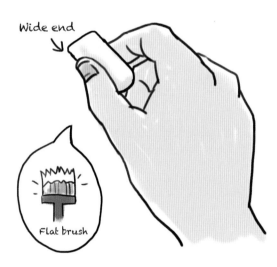

Wide end

Flat brush

The pencil and the kneaded eraser make for an odd couple!

Other ways to use the eraser

You can tap the eraser against shaded parts of your drawing to create a soft mottled texture. There are many effects you can create with the eraser. The eraser is a vital part of your toolset. Mastering the skill of using your eraser well is just as important as the mastering the use of your pencil.

Practice Observing the Object

Identify the object

If you are someone who studies art, you must've been told once or twice to "properly observe an object." You stare at an object for 15 seconds straight, hoping to get a better look. You might be *looking* at the object, but not *observing* it. Here are 6 pointers on how to observe and identify the object's properties.

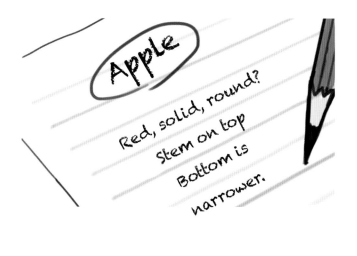

Record the object's traits

Now to get down to business. This may not be necessary, but it's a fun exercise. Write down the traits of the object. If it's an apple, you'd write things like, "red," "round," etc. It's not unlike a police officer writing down a description of a suspect. Take notes with many details.

Look at the object in 360 degrees

There are many angles from which to observe to an object. When you want to sculpt something, you can't begin after only observing it from a single perspective. The same can be said of drawing. It is helpful to understand the attributes of the object as a whole.

Feeling the object

This time, try feeling the object with your eyes closed. You might notice textures, bumps and dimples that you didn't detect through visual inspection alone. While you are feeling the object, register the shape in your mind.

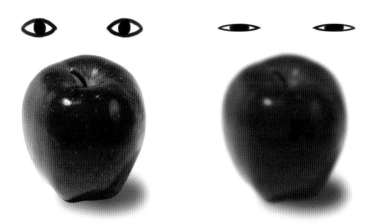

Squinting

Try squinting while observing the object, to make it appear as blurry as possible. When the object is blurred, you can distinguish light and shadows more easily. This is a handy trick to use for drawing.

Looking at the gaps between objects

Just like the piece "Rubin's Vase," there are different ways to view the same object. Try looking at the space between and around objects, and see what kind of shape it forms. Take a look at the red image to the right. If you look at the space around an apple, this is what you may see. It might take some practice to become proficient in seeing objects this way.

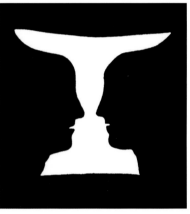

"Rubin's Vase." The black portion looks like two people facing each other, while the white part is the vase.

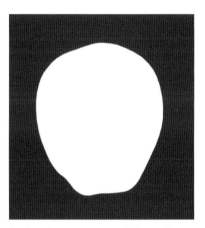

Seeing the space around the apple.

Guessing game

You can play a guessing game with a friend by describing the object's properties taken from the notes you've made on an object. See what those properties reveal about the object. Can your friend guess what the object is? Then, express those descriptions in your drawing. A lemon is yellow, roughly shaped like a football, firm but slightly yielding, and the surface is pebbly. Have you practiced drawing these attributes? Your observation skills will become sharper after you put these pointers into practice.

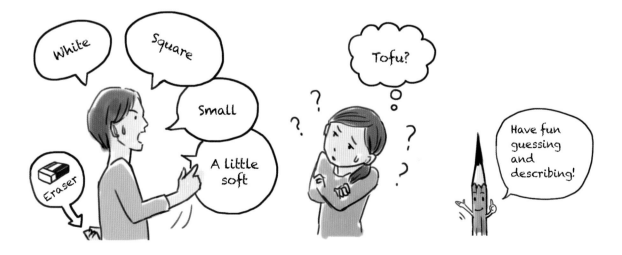

Understand the Five Basic Techniques
Make it your goal to learn to draw more realistically

Art doesn't have to be realistic, of course, but this book will show you how to draw realistically. The five basics include: position, lighting, shape, texture, and spacing.

1

How to determine position

To determine the position of the object means to decide how to place the object on the paper. How near or far away do you want the object to appear? Learning to place and scale the object to be drawn is one of the keys to creating a successful composition.

Keeping balance in mind

You can frame the object however you want, but it is important to keep balance in mind as you plan your drawing. You can probably tell when something is kind of "off" when something about the positioning is bothering you.

One of the simplest ways to determine the position is to frame your subject with your fingers.

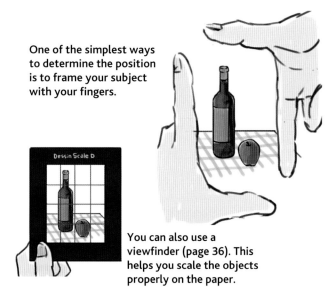

You can also use a viewfinder (page 36). This helps you scale the objects properly on the paper.

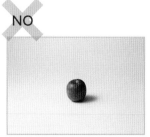

NO

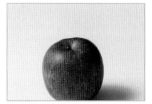

Too small

Too large

Too much to the side

Bleeding off the edge

Centering your object

The object is the main focus of your drawing. It should be centered on your paper. Careful positioning is one of the keys to having a good drawing.

OK

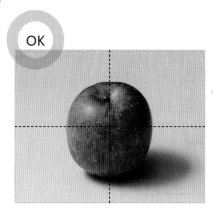

TIP Include the shadow

You can include the shadow with the object as the main image. As you can see, the elongated shadow itself adds character to your drawing. Because the shadow is also part of the main image, the positioning is adjusted accordingly.

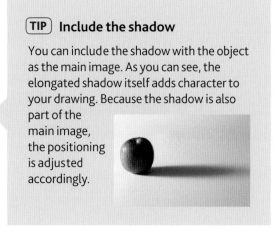

When there are multiple objects

This is not a hard and fast rule, but positioning your objects in a triangle tends to make a pleasing composition. Depending on the object's mass, you can determine which side the triangle is leaning toward.

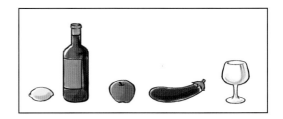

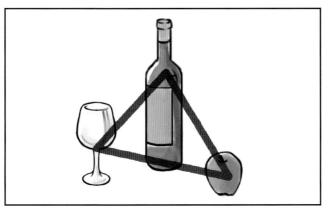

The bottle is tall, so it's positioned as the summit. It doesn't have to be dead center.

You can also determine the position by balancing the arrangement of saturated colors.

When the object doesn't fit

There may be larger objects you are planning to draw that may not fit within the confines of your paper. In those cases, focus on fitting in the important parts of the object. For example, if it is a human figure, fit in the upper half of the body. The head can be slightly cut off, as shown below.

Exploring famous pieces

What could be better than learning from the best? While you are observing classic pieces, you may notice some important patterns emerging.

The top is slightly cut off

The main focus is included, so it's okay

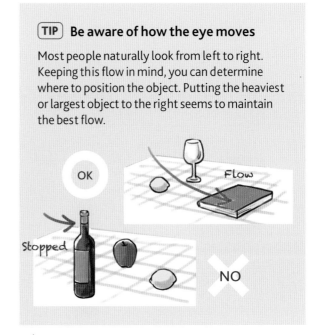

(TIP) **Be aware of how the eye moves**

Most people naturally look from left to right. Keeping this flow in mind, you can determine where to position the object. Putting the heaviest or largest object to the right seems to maintain the best flow.

Important!

It's hard to change positions and framing once you start, so try to get it right before you begin drawing!

2 LIGHTING

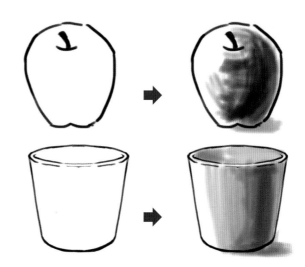

Adding light and shadows

When talking about lighting, you want to think about the light source. When drawing an object, you add light and shadow to express dimension.

Light shining on a sphere

A sphere is easy to understand. There are 3 dark shades to the sphere. The shade, the reflected light, and the shadow. The shade is where light doesn't touch the object. The shadow is the darkness created by the object. The reflected light is light from the underlying surface reflecting onto the object.

Light shining on a cylinder

The reflected light depends on the cylinder. It can be challenging to determined whether to add reflected light or not. However, the realism of your drawing depends upon it. Beginners often think the shaded areas are just dark, and overlook the reflected light. Don't make this mistake.

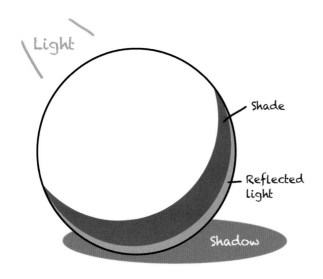

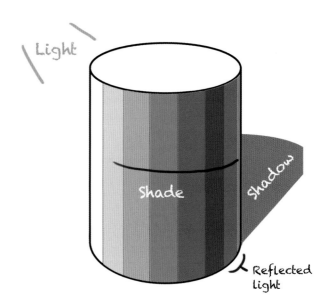

TIP **Do not forget the reflected light**

Without the reflected light, the object will look like it is floating. The reflected light is a just a subtle lightening of the shadow—be careful to not make it too bright.

Important!

28

Light shining on a cube

The shading of each surface of a cube varies from face to face. For example, if the light is coming from the top left, the top side will be the brightest. The side on the right will be the darkest. The left side will have a lighter shade. This is when your gradation practice comes in handy. Shadows and light are part of the same continuum.

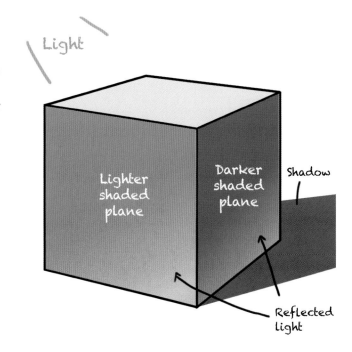

Light

Lighter shaded plane

Darker shaded plane

Shadow

Reflected light

Combining shapes

Once you practice illustrating lighting on simple shapes, you can begin to apply that skill to more complicated objects. It should go without saying: starting simply and practicing diligently are the keys to improving your skills.

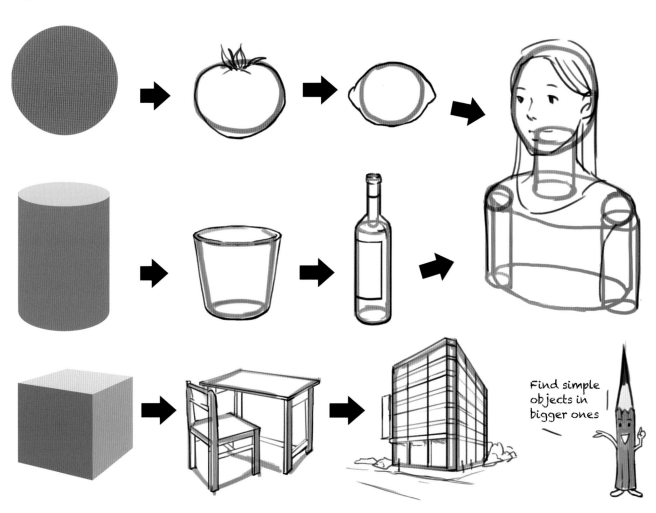

Find simple objects in bigger ones

3 SHAPE

Hand and eye

The first challenge of drawing is to become proficient at capturing the shape of the object. It's not unusual to struggle with this. No one is perfect on their first try. Just like when first starting to ride a bicycle, you must practice many times before you master the activity. Practice coordinating your hand and eye.

Here is the stereotypical pose of an artist at work. This illustration depicts someone measuring the dimensions of an object.

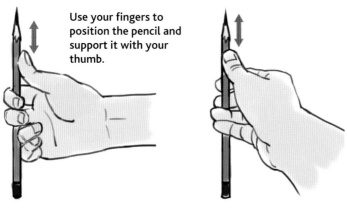

Use your fingers to position the pencil and support it with your thumb.

The right way to measure

After deciding on framing, measure your object. You should sit in front of the object where you can see it well, and stretch your arm out straight. Always keep your pencil at a right angle to your arm, and parallel to the plane of your face. Make sure you do not bend your elbow.

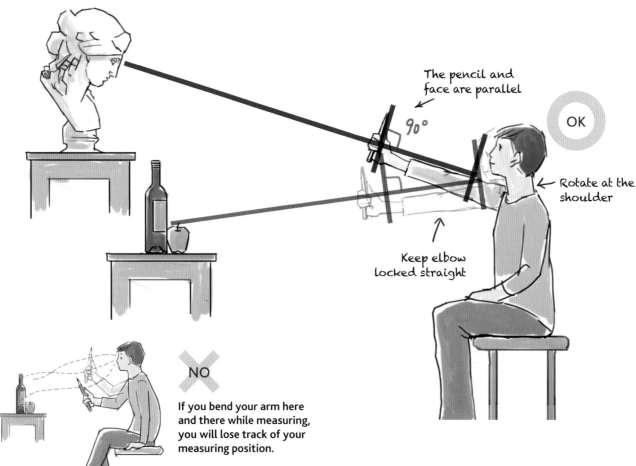

The pencil and face are parallel

90°

OK

Rotate at the shoulder

Keep elbow locked straight

NO

If you bend your arm here and there while measuring, you will lose track of your measuring position.

Measure the length & width

1

Measuring the length

Let's use an apple as an example. At arm's length, align the tip of your pencil with the top of the object. Next, adjust the position of your thumb so it aligns with the bottom of the object, as shown.

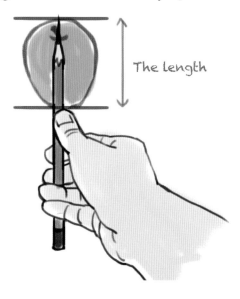

The length

2

Measuring the width

Rotate your hand to make the pencil parallel to the floor. Remember to keep the pencil parallel to the plane of your face. Keep the alignment of length measurement, and measure the width by comparing it to the length.

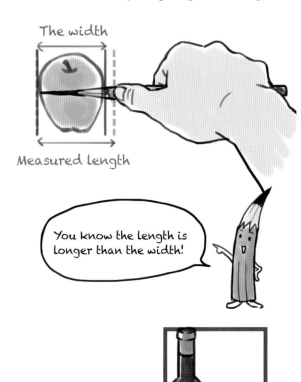

The width

Measured length

You know the length is longer than the width!

Try measuring grouped objects

1

When you place your objects, consider how you can frame them in a box. See the red outline on the right.

TIP In other words, if you can fit this box on your paper, the composition will fit!

2

The overall length of the image is A, and the overall width is B. Compare the proportion of each, and make a rough calculation. A is perhaps 1.8 times the distance of B. While you're at it, you should determine the center of the overall image.

center point

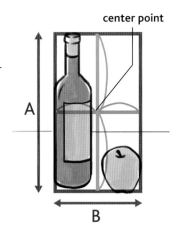

A

B

3

Compare the proportions of each of the objects. Take a measurement and estimate the difference between them. How many of C can fit into D?

TIP For vertically-oriented shapes, always take the measurement by the length. Since the width is horizontal, it is difficult to take an accurate measurement that way.

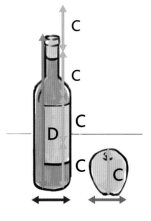

C

C

C

D

C

C

1

Checking the vertices

Next, take a closer look at the vertices of each object. As you can observe below, the red dots indicate the peaks and valleys of each object. Can you find the general shape of the objects?

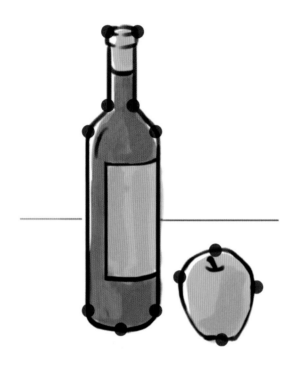

2

Checking the relation of the vertices

Now take a look at A and B. See the peak of the apple in relation to the wine bottle. Do the same with C and D. Look at the lowest point of the bottle, and roughly where it falls in relation to the apple. This is to prevent disproportion in your drawings. Carefully gauge the proportions and their relationships. You can also use a viewfinder for this purpose (page 36).

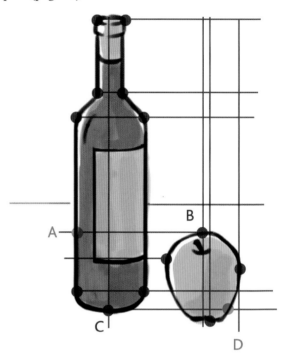

Once you've taken the measure of your objects, sketch them out

While you should get a good grasp of the general proportions, try to start your sketch without becoming overly fussy about the measurements. You don't want to tire yourself out before you even start. Remember, with practice you will become more proficient with shaping and measuring proportions. Use a B pencil to outline the shape while you observe measurement and proportions.

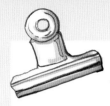

Understanding structure and perspective

Identifying mistakes

No matter how hard you work on measuring, the position of your hands and eyes will always be a little out of alignment, leading to mistakes in your drawing. When this happens, it is helpful to know how to identify your mistakes. Understanding structure and perspective will be useful in this process.

Looking at cylinders

The closer to eye-level a cross section is, the more oval it looks. The farther away it is, the more it looks like a circle.

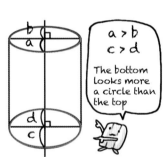

$a > b$
$c > d$

The bottom looks more a circle than the top

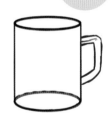

NO — Avoid pointed ends on your circles!

OK

For mugs and glasses (pages 52 and 70), people often draw pointed ends on the rims. No matter how you look at a cylinder, cross sections are always curved.

For cubes, understanding perspective is important (see the explanation on page 56). The "NO" cube below illustrates a common mistake. The lines are parallel, but as you can see, the shape doesn't look quite right. Carefully observe the vertices on the model. If you are mindful of perspective, you will avoid this common problem.

Looking at cubes

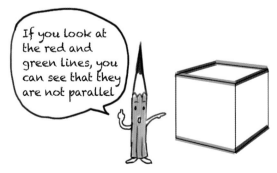

If you look at the red and green lines, you can see that they are not parallel

NO

OK

4 TEXTURE

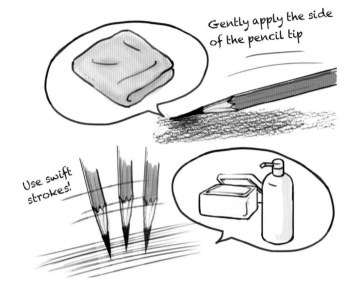

Gently apply the side of the pencil tip

Use swift strokes!

The art of expressing texture

Drawn texture conveys a representation of the way the object feels to the viewer. The surface you're trying to emulate could be bumpy, soft, hard, scratchy, shiny, metallic, etc. If you want to draw something soft, shade it in with a B pencil. Or if you want to illustrate hard surfaces, use an H pencil and execute swift strokes. With other textures, you can put your eraser to use as well.

Methods of expression

Just as I detailed on page 22, there are different ways to handle your pencil and eraser to create many effects. After you grasp the basics of lighting and shaping to a reasonable extent, you will want to learn ways to convey the appearance of textures. Even with these pointers, you will develop many techniques of your own through trial and error.

That's why it is important to get to know your tools!

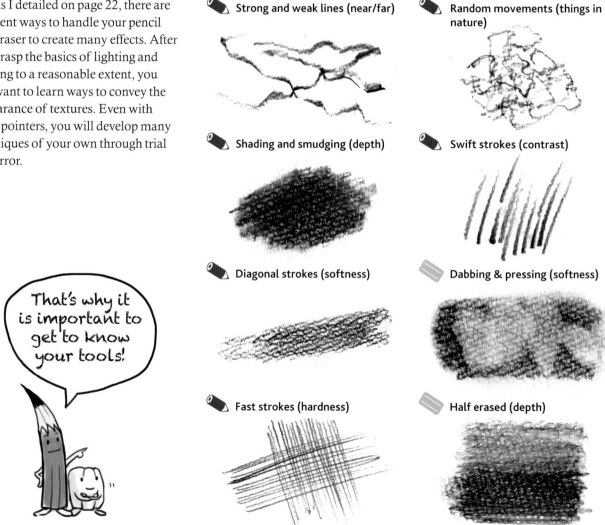

Strong and weak lines (near/far)

Random movements (things in nature)

Shading and smudging (depth)

Swift strokes (contrast)

Diagonal strokes (softness)

Dabbing & pressing (softness)

Fast strokes (hardness)

Half erased (depth)

5 SPACING

Expressing depth and dimension

All objects exist in space. Imparting depth and dimension to your drawings is a way to communicate to the viewer that the object has a physical existence.

Look at two objects placed in series

As the illustration shows, the lemon has been placed closer to the viewer. The box is farther away. Point B is farther away than point A. Use the lemon as a point of reference for depth. When drawing, use the object nearest you as a point of reference to see the contrast between it and objects behind. You can also use light or bold lines to indicate depth. Bold, sharp lines for nearer portions of your composition, and progressively lighter lines for portions that are farther and farther away.

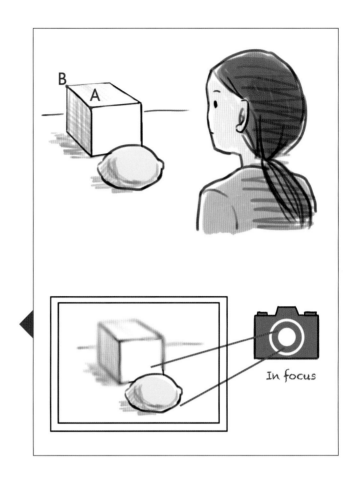

Use line weight to express spatial contrast

Bolder in front, lighter farther back

Shading & smudging can express spatial contrast

Soften the shading on the parts that should appear farther away from the viewer

Directionally shade in alignment with the surface

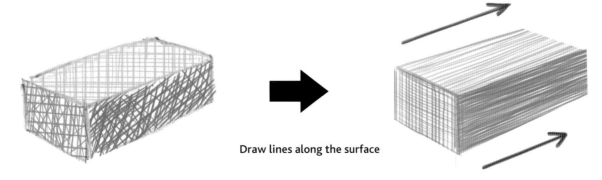

Draw lines along the surface

How Do You Use a Viewfinder?

It can be challenging to frame large objects and determine their shapes. This is when a viewfinder (or "drawing scale") comes in handy.

What is a viewfinder?

A viewfinder is one of those tools people generally aren't familiar with. However, artists use them quite often. When transferring an image to paper or canvas, a viewfinder helps you scale the image to fit the size of your paper. It's not necessary to use this tool, but it is a handy way to check your proportions.

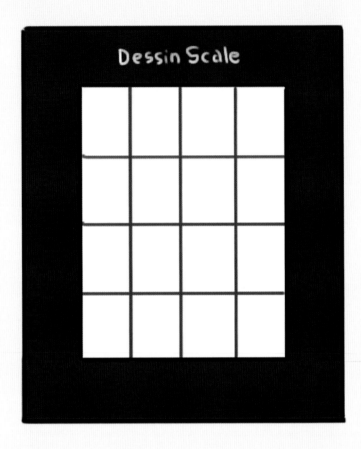

Dessin Scale

Make your own viewfinder

It's actually very easy to make your own viewfinder. Just make a simple frame from cardboard using the same proportions as your drawing surface, and then tape or glue on strings to make the grid lines!

1 Draw the lines of the viewfinder onto your paper. Make sure the lines are in proportion to the viewfinder.

2 Hold the viewfinder up to the object to be drawn. Stretch your arm out and hold the grid at a right angle.

3 Decide how you will position the objects to be drawn on your paper (page 26).

4 Check the center of the image. Use each box in the viewfinder to break the image into manageable chunks and guide you through the contours of your drawing as you work.

How to hold the viewfinder

Similar to the way you use your pencil to measure proportions (page 30), you stretch your arm out and keep it straight. Also, make sure to hold the viewfinder parallel to the plane of your face. This is done to keep your measurements consistent.

OK

NO

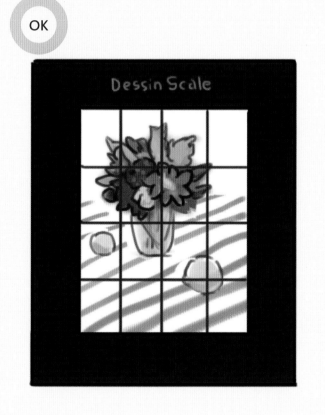

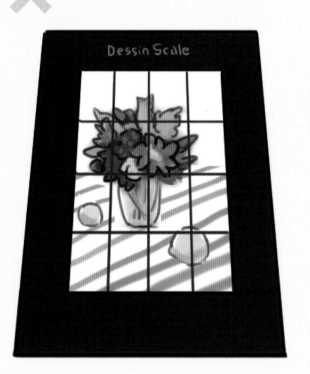

What is a Surface?

I have used the term "surface" quite often in the preceding pages, but what does it really mean?

Carving out the surface?

The process of roughing in a drawn facsimile of a surface can be illustrated by comparing it to the process of carving wood. For instance, if you try to carve a piece of wood into a sphere, it would be impossible for you to immediately arrive at a rounded surface. When you chisel away at a part of the surface, you get a "face," which is a flat surface. Then, as you refine and trim away the excess material, the sphere begins to take shape, and you can see the object becoming closer to the final product.

Drawing the surface?

Drawing is quite similar to carving when it comes to roughing in the surface of an object. The sketch may be a rudimentary, choppy-looking form of the actual object at first, but then you start to refine the angles until the final image emerges.

"Lines over surface?"

In Western art, the focus has traditionally been on the appearance of surfaces. Whereas in Asia, art has historically been predominantly line based. Even today, Japanese manga is a clear illustration of the "lines over surface" approach. In this book, I am teaching the Western method of drawing.

Part

2

Drawing Lessons

In this section, I present drawing lessons for common household objects. You can jump into the lessons anywhere to draw whichever object you prefer.

Basic Steps

Your process will vary depending on what you are drawing, but here is the basic process of putting your drawing on paper.

1

Find the center of the paper
Measure the length and width of your paper and lightly mark the center.

TIP

At the outset, draw a centerline to properly define the composition. This is especially helpful when making technical drawings or compositions with multiple objects.

Measure with a long pencil

You can always use a ruler, but it is easy to measure with your handy pencil. Place the pencil on the edge of the paper and mark it (A). Place the same pencil on the opposite end and mark again (B). Make a mark in the middle between A and B. If you repeat this process on the other three sides, you'll be able to find the center of the paper.

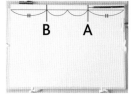

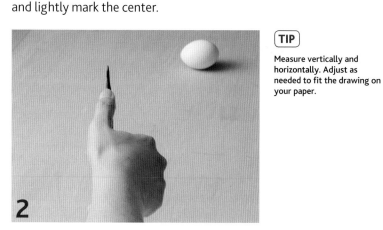

2

Measure the object
Measure the length and width of the object with your pencil. Frame the object in a rectangle (page 31). Find the intersecting point of the length and width.

TIP

Measure vertically and horizontally. Adjust as needed to fit the drawing on your paper.

Measure as you work

Check each vertex vertically and horizontally to confirm their positional relationships. Follow an imaginary line from a landmark to the other side of your drawing and compare its position to what you observe on its real life counterpart.

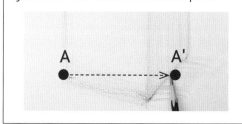

3

Sketch the general shape
With your pencil held diagonally, sketch out the shape of the object. You are not "drawing" the shape, you are roughing in the significant points of the shape.

TIP The lines serve as a guide for determining the position of the object.

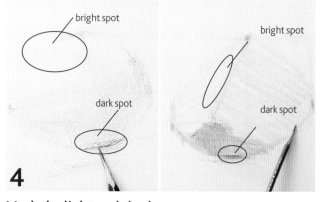

4

Mark the light and shadows
Evaluate how the light strikes the object and start to define the shadows. This is how you will start to visually describe depth.

TIP Mark the bright and dark spots to lay the groundwork for shading.

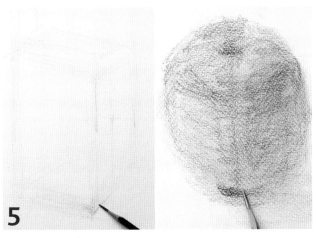

5 Shading in the bottom
Once you've established the general shape, anchor the object in place by shading in the base.

> **TIP** Shade in the darkest part of the base when you're ready to commit to turning the light sketch into a full drawing.

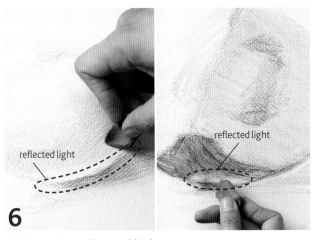

6 Adding the reflected light
Before you move on, use your kneaded eraser to add the reflected light (page 28).

> **TIP** Using the eraser to remove shading, rather than trying to define reflected light by shading around it, makes the reflected light look more natural.

reflected light

reflected light

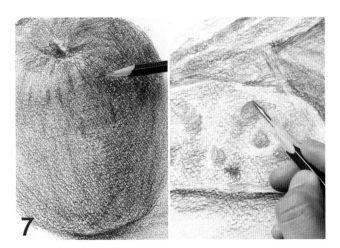

7 Switching Pencils
As the shading progresses, change the pencils accordingly. B pencils for softer lead and darker marks, H pencils for harder lead and lighter marks.

> **TIP** If you do this too early in the process, you may scratch the paper. Once the paper is damaged, the marks will not disappear even after erasing.

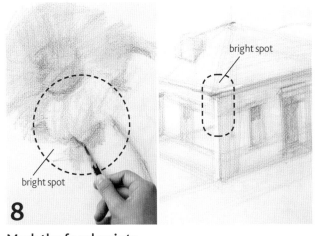

8 Mark the focal points
Once the shape is put together, mark the focal points and areas of high contrast (page 35). This is the step where you organize the composition of your drawing.

bright spot

bright spot

bright spot

> **TIP** Be careful to not mark too many spots, because this has the effect of flattening your drawing.

Other things to look out for

Take breaks
It is important to take a break at least every 30 minutes. Working on a piece for a long time could deteriorate your ability to keep your strokes even, and your vision sharp.

Take a picture
If the lighting will change with the movement of the sun, or the object itself might be moved, take a photo of the subject you are working on. You might also mark the position of the object with tape, to record exactly how the object was positioned.

Final touches
While sketching, you may end up with extra lines that extend past the edge of the drawing. Tidy up any unnecessary lines with your kneaded eraser. Once final adjustments are completed, preserve the drawing with workable fixative spray (page 13).

Apple

An apple is a simple familiar object. Select the most well-formed, dent-free apple that you can.

Photo example

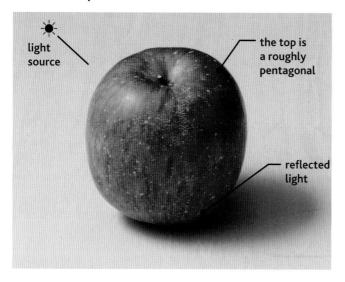

light source

the top is a roughly pentagonal

reflected light

Basics to apply (pages 26–35)

POSITION SHAPE

LIGHTING TEXTURE

Your composition should be slightly larger than actual size. That way it will be easier to work on. Place the apple slightly to the left of center on your paper to leave room for the shadow. Because the red of the apple is quite saturated, the whole image will come out relatively dark, so plan on significant shading. You may think of apples as being roughly spherical, but the top part is actually defined by a roughly pentagonal shape. You can use straight lines first, and then blend the shapes together (page 38).

Completed drawing

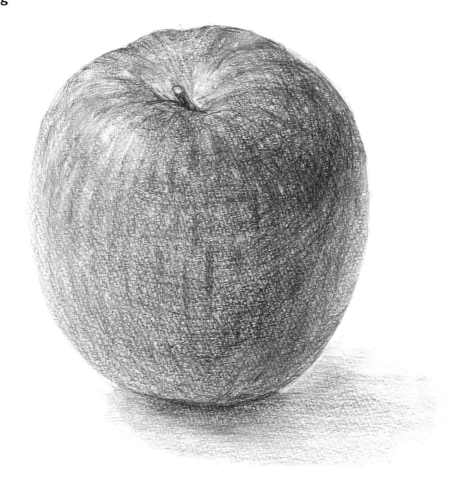

1

Sketch in some guide lines. Check the proportions, and measure the length and width. Use a B pencil during this process.

TIP Anchor your drawing's position on the page by working from bottom up.

TEXTURE

2

With broad strokes, shade in the length and width. The "red" parts will become considerably dark, so begin roughing in the shading now.

3

Blend the light shading with a tissue (page 22).

TIP You can also just use your fingers.

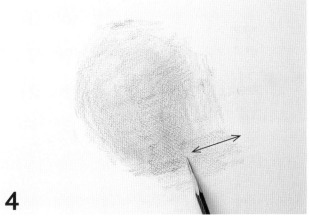

4

Instead of drawing in the shadow separately, add those shades as you go in horizontal strokes.

TIP Think of the shadow as part of the object.

5

"Color" in along the contours of the surface.

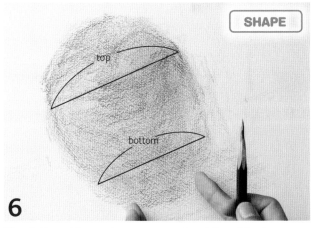

SHAPE

top

bottom

6

Check the wider and narrower parts of the object.

TIP Keep in mind that while the apple is basically round, the top of the apple is actually a pentagon.

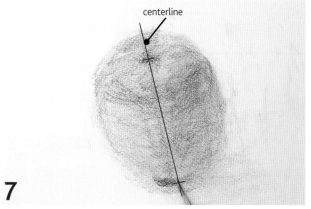

centerline

7

Find the centerline of the object, add the stem part of the apple (page 41).

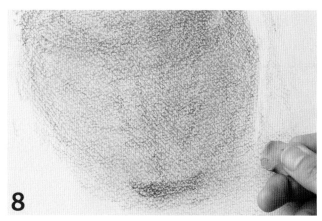

8

Use the kneaded eraser to define the edges.

TIP Think of the kneaded eraser as a "white pencil."

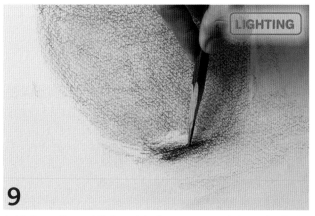

LIGHTING

9

Add the reflected light with the eraser, and then shade in the shadow.

TIP To anchor your drawing to the paper, work from the bottom up.

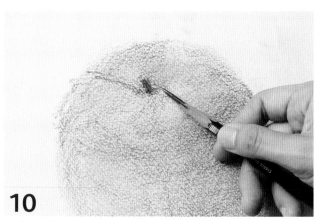

10

Define the stem part to your satisfaction.

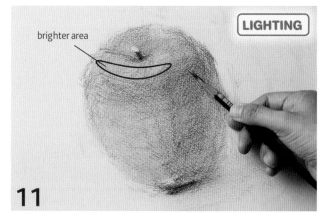

brighter area

LIGHTING

11

Avoiding the brighter areas, shade in the darker areas with your pencil.

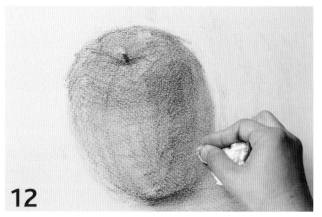

12

Make the parts that are farther away blurrier, and the nearer parts sharper.

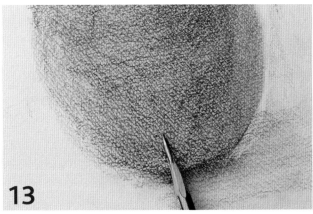

13

Continue to fill in the shading (gradation).

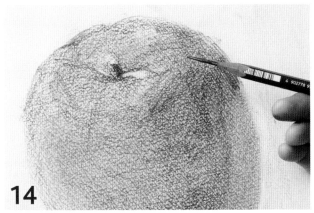

14

When adding the fine details of texture, bring out your harder HB pencil. Use a detail grip during this process.

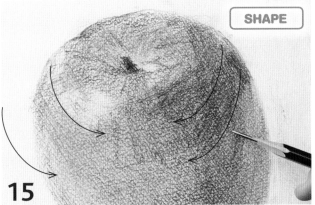

SHAPE

15

Use curving horizontal lines to emphasize the impression of roundness.

TIP This is different from shading. The visible strokes are to suggest the roundness of the shape.

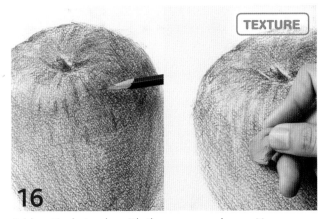

TEXTURE

16

Add vertical streaks with the eraser as shown. You can see the apple becoming realistic.

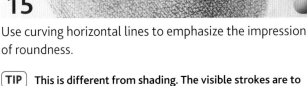

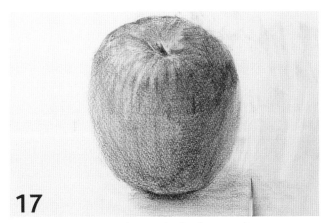

17

Switch to the H pencil to make final tone adjustments as necessary.

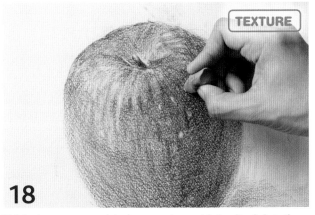

TEXTURE

18

With the eraser molded to a point, add the final details, such as the brighter spots that are visible on the apple.

TIP Be careful to not overwork the drawing.

Drawing Simple Shapes 45

Lesson **2**

Milk Carton

Practice emulating three-dimensionality by drawing a simple carton with straightforward lighting.

Photo example

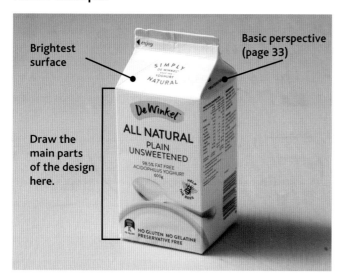

Brightest surface

Basic perspective (page 33)

Draw the main parts of the design here.

Basics to apply (pages 26–35)

POSITION SHAPE

LIGHTING TEXTURE

Position the container at an angle to view the object from slightly above eye level. Take note of the shadow as you are adjusting the lighting. Try not to get into too much detail with the graphic design printed on the carton and be careful to get the perspective right (page 56). Since this is a simple man-made object, drawing mistakes will be obvious, so proceed with caution.

Completed drawing

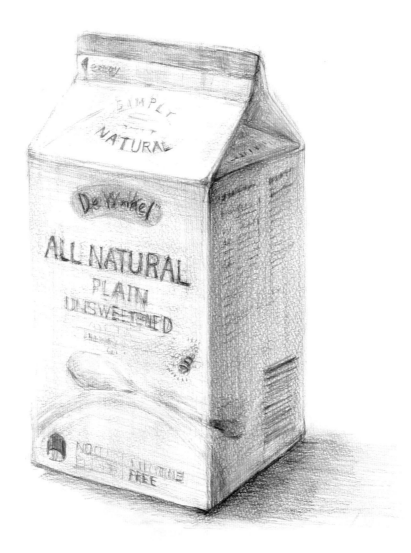

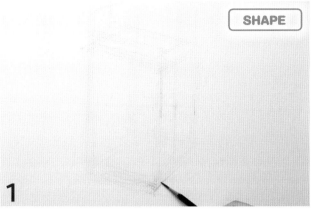

1

Define the vertices and relationships between each point. Check the proportions, and measure the length and width. Use a B pencil during this process.

TIP Because this is a man-made object, make sure you take accurate measurements.

2

Mark the base of the carton (page 41).

TIP Use the base as the anchor point for the rest of the drawing.

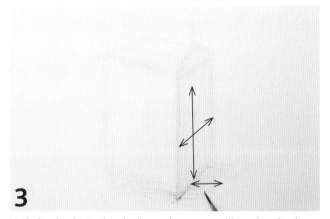

3

Lightly shade in the darkest plane, as well as the shadow.

TIP Keep in mind that the shadow is part of the object.

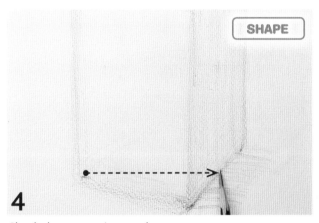

SHAPE

4

Check the proportions and corners as you go.

TIP To ensure that your drawing is not becoming skewed, reinforce it by checking the shape constantly. Mistakes can be fixed if you catch them early enough.

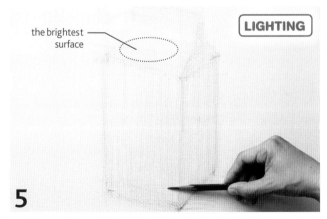

the brightest surface

LIGHTING

5

Lightly shade in each surface. Don't shade the brightest surface.

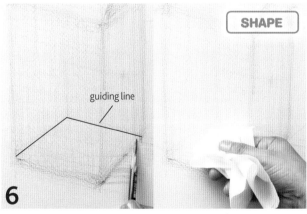

SHAPE

guiding line

6

Lightly draw in the back part of the shape (as if the object was transparent), just to support your understanding of the 3-D shape of the object. Blend the line away with a tissue when you've finished sketching the carton.

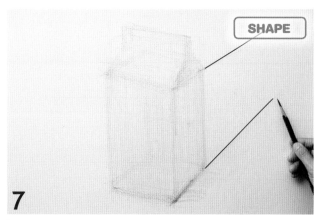

7

Use two-point perspective (page 57) to determine the shape.

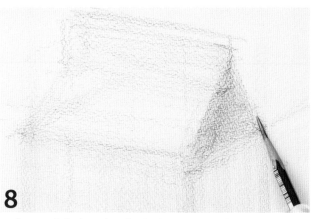

8

Define and darken the shaded portion at the top.

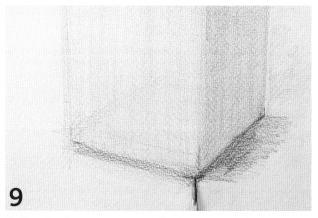

9

Define the bottom area and shadow around the base.

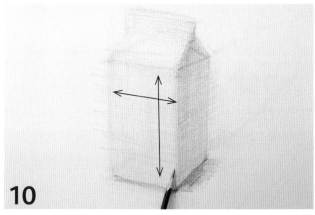

10

With wide strokes, shade along the surface, with lines sticking out past the edges, as demonstrated here.

TIP If you try to stop shading at the edges of the carton, the edges might become unintentionally dark, so make wide strokes, and those extra lines can be erased later.

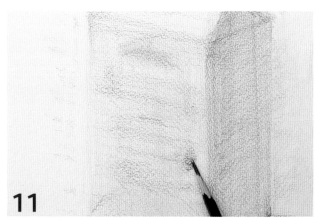

11

Add in indications of the design printed on the carton. Try not to work on the details here too much.

TIP Don't try to complete the design here. Add hints of it as you go.

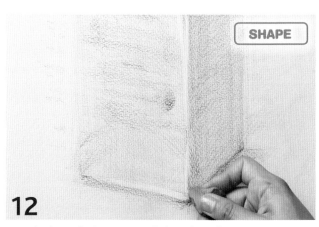

12

Use the kneaded eraser to define the edges.

TIP This is to reinforce the shape. You will be further adjusting it later on as well.

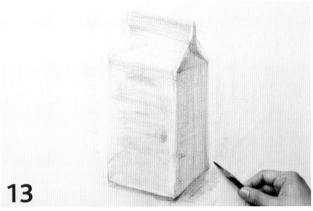

13
Shade in all of the surfaces.

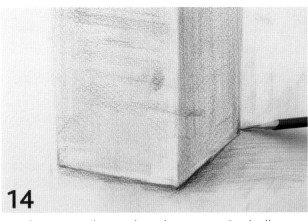

14
Use the HB pencil to work on the texture. Gradually adjust as you go.

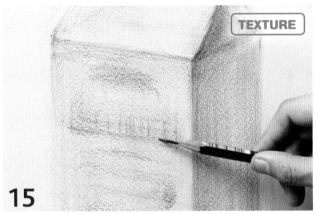

TEXTURE

15
Position the type of the design, in this case "ALL NATU-RAL." Draw from the center.

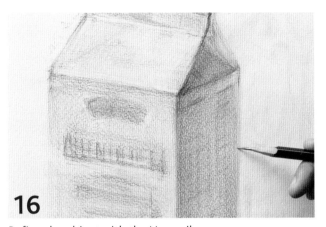

16
Refine the object with the H pencil.

> **TIP** The shade will deepen with the H pencil, so you'll start to see the illusion of depth emerge.

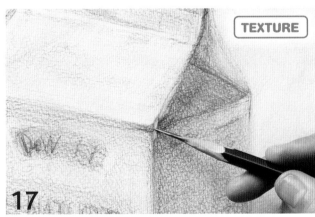

TEXTURE

17
Holding the pencil in a detail grip, work on the folds of the milk carton.

> **TIP** In this way, the characteristic look of the carton will begin to appear.

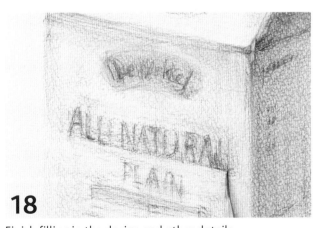

18
Finish filling in the design and other details.

> **TIP** It is unnecessary to get into the fine details of the printed graphic design. Simply indicate enough to give a sense of the design.

Lesson 3

Egg

The egg is a simple form, making it good practice for drawing a three-dimensional oval shape.

Photo example

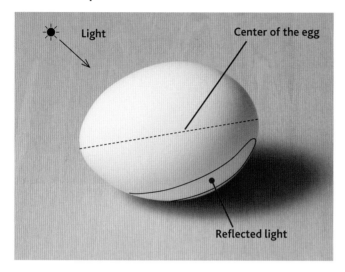

Basics to apply (pages 26–35)

LIGHTING SHAPE TEXTURE

Observe where the light and shadows fall. Take a good look at the shape, and find the center of the object, which will be the point nearest you. The egg is white, so there won't be too much shading to add. Start with a B pencil and move to an H pencil for subtle gradation.

Completed drawing

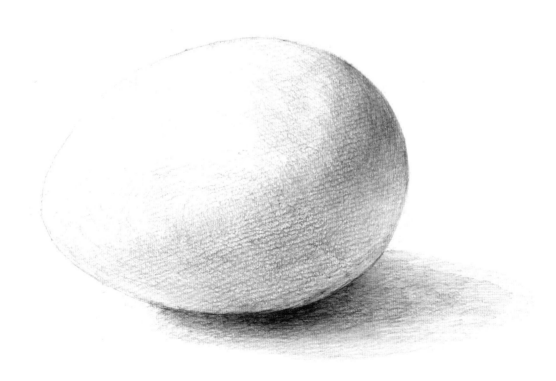

SHAPE

centerline

1

With the soft B pencil, sketch out the shape of the egg. Add the centerline.

TIP The brightest part of the egg will have the lightest shading.

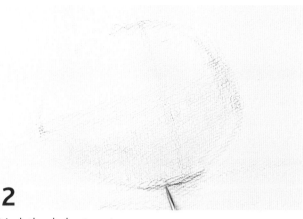

2

Mark the darkest spot.

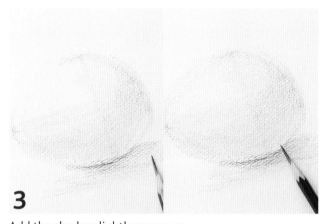

3

Add the shadow lightly as you go.

TIP Think of the shadow as part of the object and add it as you work on the whole object.

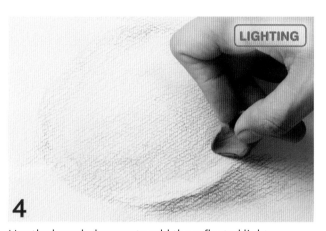

LIGHTING

4

Use the kneaded eraser to add the reflected light.

TIP Be careful not to overdo it—erase gently and gradually.

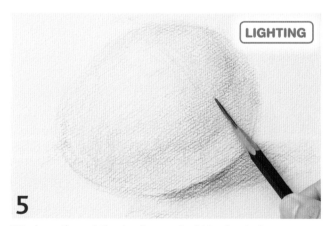

LIGHTING

5

Work on the subtle shading and add in the darker areas.

TIP Be careful not to put down too much color. Use an H pencil during the gradation process.

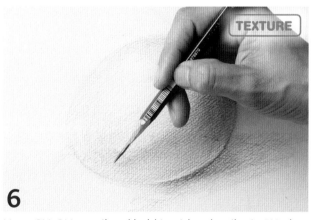

TEXTURE

6

Use a 2H–3H pencil and hold it with a detail grip. Work on the fine details.

TIP Work on the subtle variations of the gradation.

Lesson 4

Mug

Drawing a mug is a good way to practice drawing a cylindrical shape. Choose a mug with straight sides.

Photo example

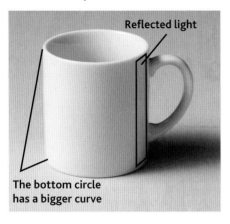

Reflected light

The bottom circle
has a bigger curve

Completed drawing

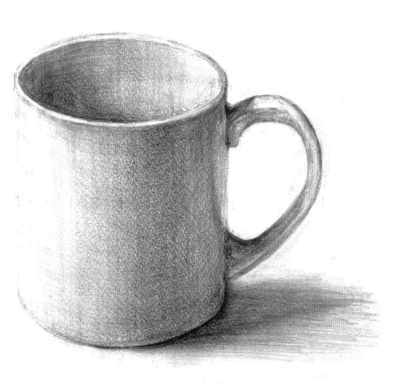

Basics to apply (pages 26–35)

LIGHTING · SHAPE · TEXTURE

This example shows a mug that is straight, like a chimney. The foundation of this shape is a cylinder (page 33) Because of your eye level, the top and bottom ovals appear different. The bright parts are made by using the eraser. Fast strokes of the H pencil will express the curves of the object. Pay close attention to the gradation of this object.

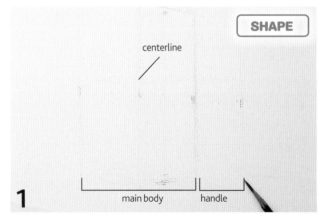

SHAPE

centerline

1 main body · handle

Work on marking the outline and measuring out the proportions of the object. Find the centerline of the object to define the curve of the object. Use a B pencil during this process.

TIP The centerline is where both left and right halves are symmetrical. The handle is a separate shape from the body.

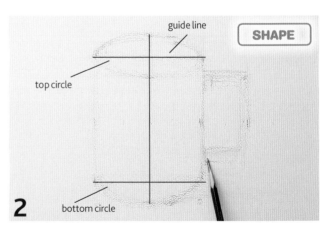

guide line

SHAPE

top circle

2 bottom circle

Draw out guide lines as demonstrated to draft the top and bottom circles.

TIP The curve of the bottom curve is more rounded than the top.

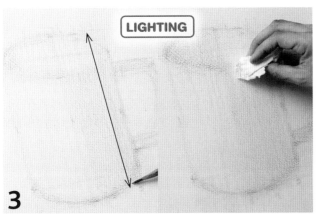

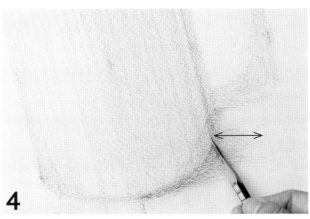

3

Observe the light and dark areas of the image. Shade the surface with broad strokes, allowing them to run beyond the edge. Use a tissue to blend in the shading.

TIP If you try to stop the strokes at the edge, it will become unevenly dark. Let the lines run past the edge and erase them later.

4

Add in the shadow.

TIP Think of the shadow as part of the object and work on it at the same time as you're drawing the object.

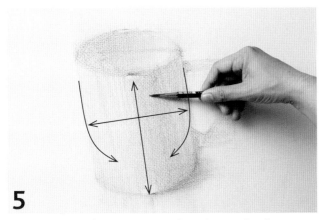

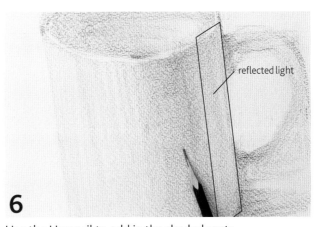

5

Add strokes in the appropriate directions to lend an impression of roundness.

TIP This is to guide further detailed gradation.

6

Use the H pencil to add in the shaded parts.

TIP Don't shade over the reflected light surface.

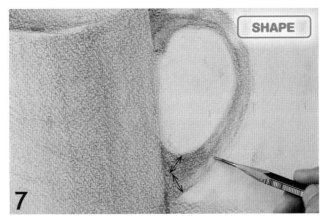

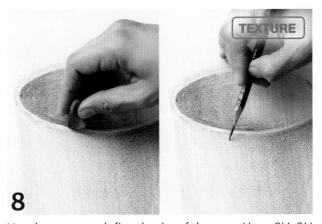

7

Place the handle. Add in the shadows and highlights as well.

8

Use the eraser to define the rim of the mug. Use a 2H–3H pencil held with a detail grip. Further define the rims, and other fine edges.

Drawing Inspiration

Simple Shapes

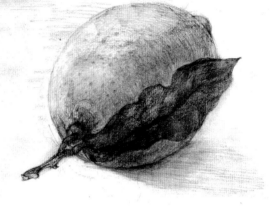

Lemons from the Garden

You can rotate a lemon and work on it from many angles. Practice creating surface texture. If possible, use a lemon with a leaf attached to practice creating the associated contrasting tones.

Acorns

You can draw inspiration from seasonal objects. The acorn is small, so try using a mechanical pencil to work on the very fine details.

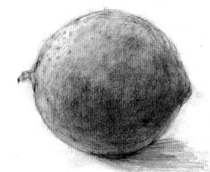

Tomatoes on the Vine

You can work on many tomatoes all at once. Tomatoes are saturated with color and it may be fun to work with the dimensions and different "colors" if you decide to try this.

Glasses

This seems like a relatively simple object at first, but there are many factors at play. Work with the transparent surfaces and elongated shadows. You can do all of this with an HB pencil, as if you are doodling.

Teapot

The hard metallic surface is another texture to master. The gradation in this object is a great one to practice.

Laundry Detergent

It's a fun challenge to work with the logos of packaged commercial products.

Understanding Perspective

Getting the basics of perspective down is very important when defining the shape of an object.

What is perspective?

When capturing the shape of an object, it is necessary to understand the concept of perspective. If you know this, you can envision the structure in your mind even while you are drawing, and it will be easier to avoid mistakes. Although not essential for drawing, solid knowledge of the concept of perspective will increase your range of expressions.

What's wrong? Check the cube

Look at the image on the right. Does something about it bother you? For example, does part of it appear to be convex or concave? Does the back look wider than the front? What seems to be the problem?

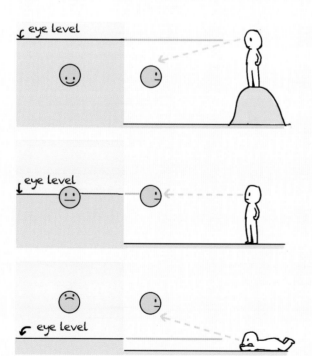

Understanding the principles of perspective

To briefly explain the perspective principle, it is a scientific methodology that explains the phenomenon where roads and buildings, etc. gradually become smaller and smaller as they approach the horizon, as seen in landscape photography. Your eye level and the vanishing point are set on a line, and the sense of three-dimensional distance is produced by lines converging toward points on the horizon.

One-point perspective

In this illustration, the lines are concentrated toward one point in the distance. The convergence of this line will be at your eye level. This method of drawing is called one-point perspective. This condition is met when you and your target are in front of you.

It looks like A if you look at things from below, and it looks like B if you look at things from above. The lines receding into the distance radiate from a single point—they are not parallel.

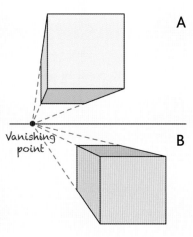

Two-point perspective

This method is used when an object is viewed diagonally rather than head on. In this way, there are two vanishing points at eye level.

It looks like A if you look at things from below, and it looks like B if you look at things from above. The opposing sides are not parallel but extend towards the vanishing points. In other words, one-point perspective is often used to represent simple depth, while two-point perspective is used to depict greater realism.

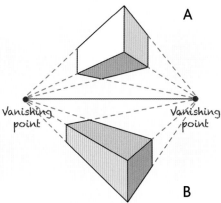

Three-point perspective

This is a technique that is used when eye level is positioned at the top or bottom of a large object. When you look at a small object that you're drawing, you usually see it from just slightly above eye level, so while three-point perspective is the most accurate (especially for large objects), the distinction is so subtle that it often isn't worth the extra effort when drawing smaller objects.

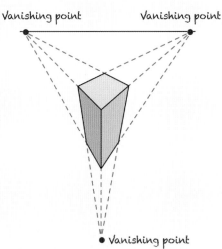

> **TIP** **The benefits of knowing how to draw perspective**
>
> Perspective drawing is somewhat mechanical, and at first you may resist applying the discipline. Because this book is about drawing things by eye, it will be tempting to avoid going to the extra effort. However, as you draw, it is worthwhile to check perspective for the sake of realism.

Lesson 5

Blanket

Choose a blanket that is not too soft and avoid complicated prints to start with.

Photo example

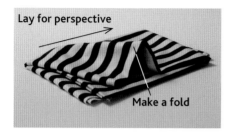

Basics to apply (pages 26–35)

POSITION SHAPE TEXTURE

If you just toss the blanket down, the stripes will become all jumbled. Folding it intentionally will make it easier to work with. If the pattern is on the larger size, it will be easier to work with. The blanket is soft, so use the B pencil to work on the texture.

Completed drawing

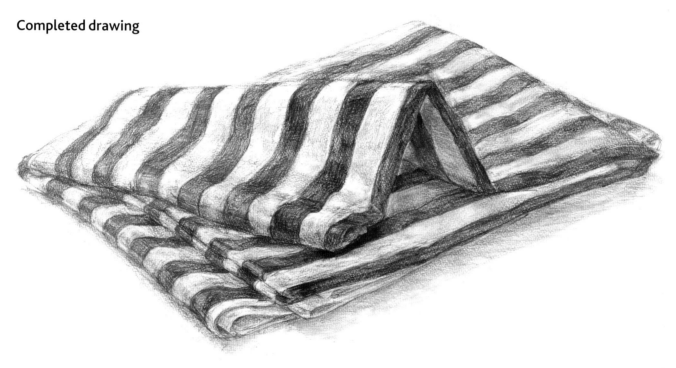

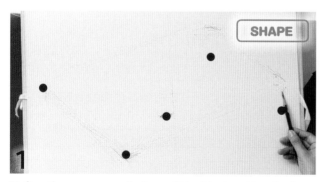

Define the creases and edges of the blanket. Use the B pencil to sketch out the rectangular shape.

Mark all the corners of the blanket.

TIP It is more challenging to render larger objects. Feel free to use a viewfinder to help.

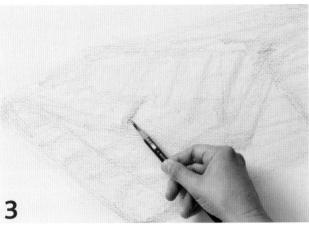

3

Measure the gaps between the stripes and start drawing them from the middle.

TIP **Starting from the center makes it easier to get the stripes evenly distributed.**

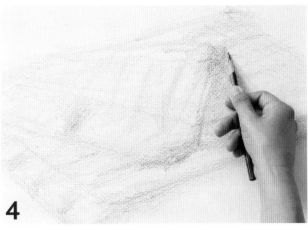

4

Add the shadows and shading to the "mountain" created by the crease of the cloth.

TIP **Where is the tip of the peak? Keep that in mind as you define the "mountain."**

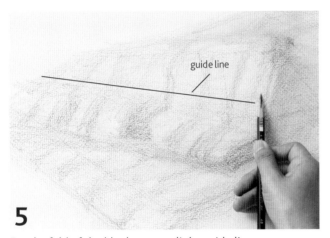

guide line

5

For the fold of the blanket, use a light guide line as you define the changing direction of the stripes.

TIP **The guide line will disappear as you shade in the artwork, so don't worry about erasing it.**

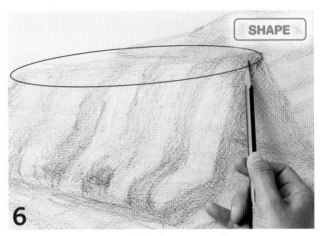

SHAPE

6

Start defining the line of the "mountain."

TIP **Even though we're calling this the "mountain," the real form of this shape is largely horizontal.**

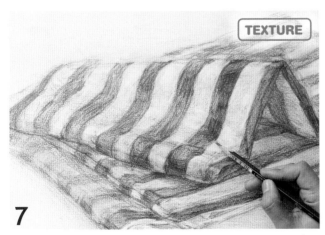

TEXTURE

7

Use a B pencil to shade in and define the stripes. Use the eraser to add gentle highlights to the wrinkles of the blanket.

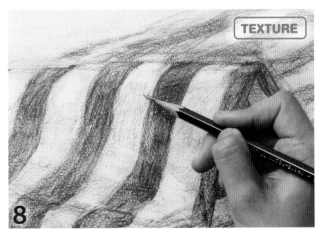

TEXTURE

8

For the finely detailed gradation, use an H pencil. Keep on working on the texture until you achieve a "soft" blanket texture.

Lesson 6

French Bread

This object is basically cylindrical. There are soft and hard parts of the bread.

Photo example

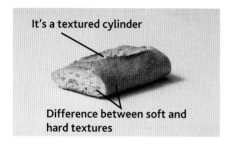

It's a textured cylinder

Difference between soft and hard textures

Basics to apply (pages 26–35)

POSITION SHAPE

LIGHTING TEXTURE

Position the bread so that you can see the cut portion facing you, but not straight on. The bread looks like a squashed cylinder. Use the soft B pencil and kneaded eraser to create the soft bread texture inside the cut portion.

Completed drawing

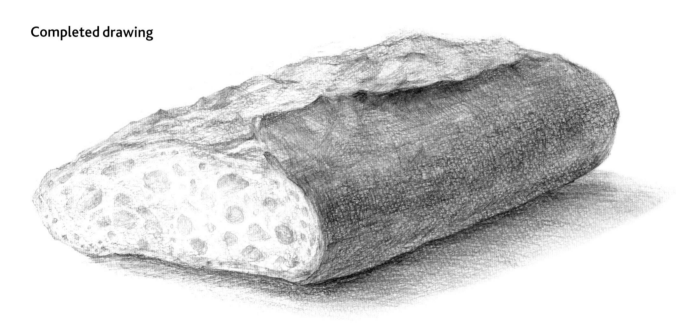

SHAPE

1

Mark each peak and sketch out the shape of the bread. Mark the base of the object as demonstrated (page 41).

TIP Think of the shadow as part of the object.

2

With wide strokes, shade in the tone of the bread in the sketched out structure.

TIP Make sure you gently shade in the light parts of the bread.

SHAPE

3

Blend in with a tissue, then define the cracks of the crust.

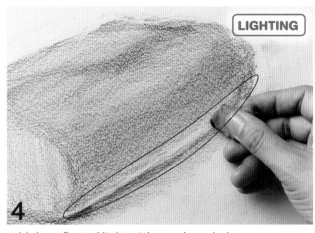

LIGHTING

4

Add the reflected light with your kneaded eraser.

[TIP] Be careful to not overdo this—you can always adjust later.

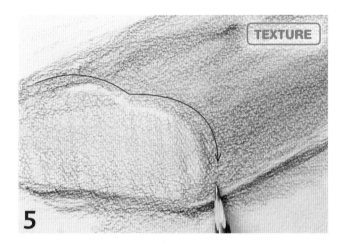

TEXTURE

5

Use a soft B pencil to work on the soft textures.

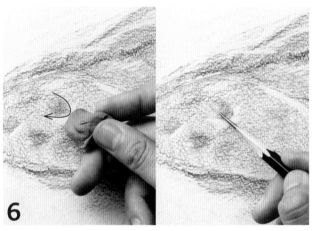

6

Create the bubbles and voids by using the eraser. Use a pencil to create the shadows in the center of the bubbles.

[TIP] Use the pencil held with a detail grip while working on the details.

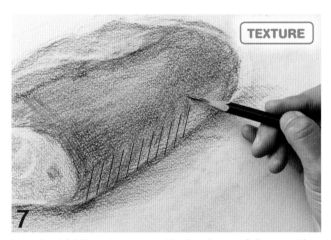

TEXTURE

7

Use straight lines to express the hardness of the crust by using and HB–F pencil. Use a detail grip to work on these details.

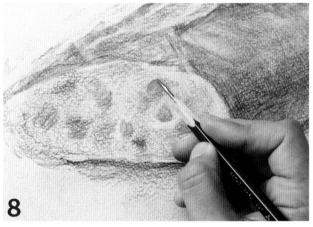

8

Add gradation in the bubbles and continue work on the crust.

Lesson 7

Rock

Find a rock with simple coloration. You will work with a lot of dents and textures on the rock (page 38).

Photo example

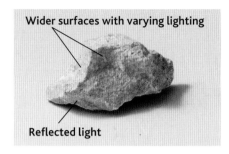

Wider surfaces with varying lighting

Reflected light

Basics to apply (pages 26–35)

LIGHTING SHAPE TEXTURE

Try to position the rock so the broadest portion is facing you, and the rock is resting securely. You want to see a side that has a good amount of bumpiness. Think of balance, positioning and lighting. We should be able to immediately recognize that it is a rock. Use the H pencil to create the hard textures.

Completed drawing

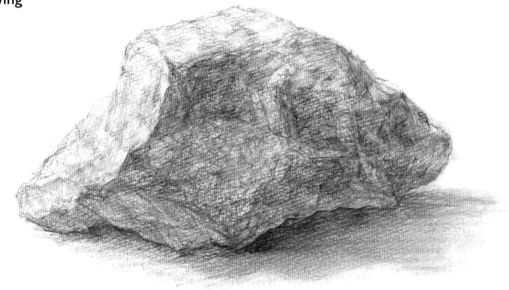

SHAPE

1

Measure and mark the point of each peaks, and check the proportions and relationship of each point. Use the B pencil to sketch out the shape.

TIP Without measuring too carefully, find the defining cracks and curves of the object.

LIGHTING

2

Check the highlights and fill in the shaded areas.

TIP Think of the shadow as being a part of the object, and work on it as you go.

3

Identify the different faces on the main surface and work on defining them.

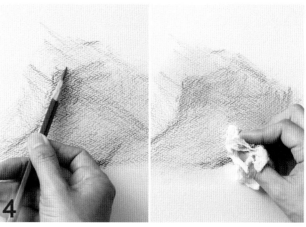

4

Make large strokes without worrying about lines extending past the edge. Use a tissue to blend.

TIP If you try to stop at the edge of the object, the edge will turn darker than it should be. You can always erase the extra lines sticking out.

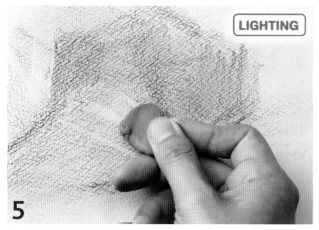

LIGHTING

5

Use the kneaded eraser to create the highlights on the surface.

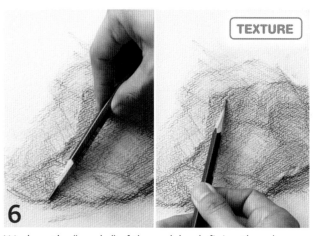

TEXTURE

6

Work on the "cracks" of the rock by defining the edges. Use the H pencil to work on the hard textures.

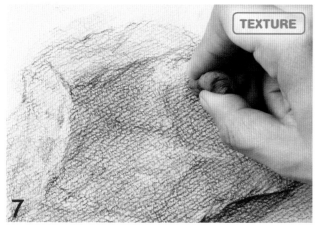

TEXTURE

7

Use the eraser to define the bumpy details on the surface.

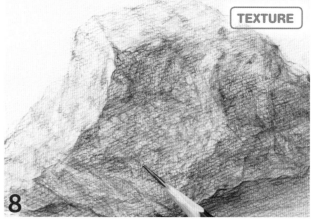

TEXTURE

8

With a detail grip, add in details as needed to create the texture until you achieve the desired level of realism.

TIP Use HB–B pencils to work on gradation.

Drawing Hard and Soft Surfaces *63*

Lesson 8

Open Book

You'll get practice drawing dimensions and textures as you work on this drawing.

Photo example

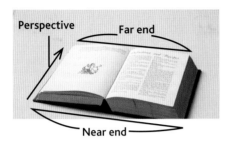

Perspective
Far end
Near end

Basics to apply (pages 26–35)

POSITION SHAPE TEXTURE

Rotate the book to an angle where you can see the side of the book—not head on. The far end should be shorter than the front end. You will be "drawing" the text on the pages rather than writing it out.

Completed drawing

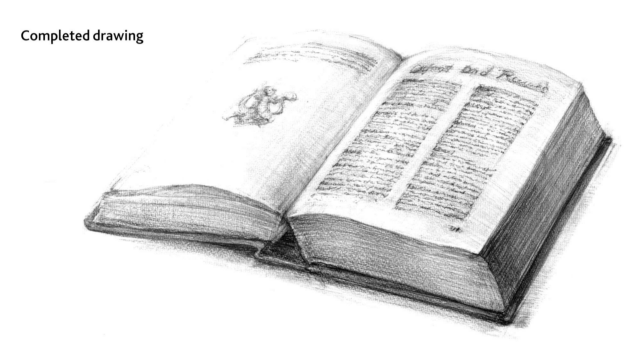

SHAPE

guiding line

1 Sketch out the curved outlines of the open book. Use a B pencil to mark the shape of the shadow as needed.

TIP The simple surface will look mostly flat at this point, as you work to define the perspective.

2 With broad strokes, shade in the edge of the pages and the open page, allowing the ends to go beyond the edge.

TIP If you stop the strokes at the edge you will end up with overly dark edges. You can always erase the extra lines later.

3

Mark and shade in the base (page 41).

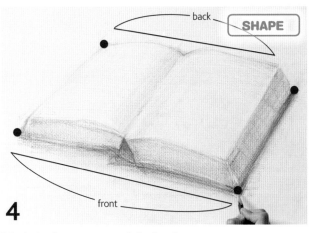

4

Mark the four corners of the book.

TIP　Remember to reflect the perspective of the object (page 56).

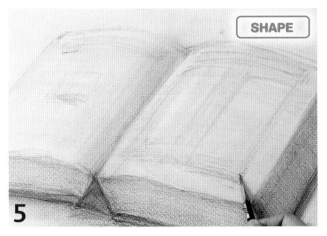

SHAPE

5

Outline the position of the text.

TIP　Remember that you are sketching the text. Block it out by paragraph or column.

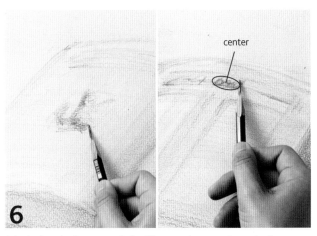

center

6

Mark the dark parts of the illustration, and mark the center of the right page.

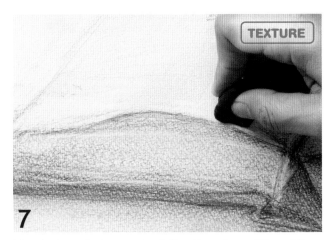

TEXTURE

7

Use the kneaded eraser to define the edges of the of the pages, and use the H pencil for the edges.

TIP　Use the pencil to bring out the soft and firm surfaces of the book.

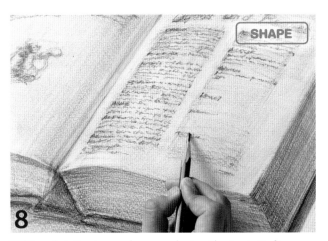

SHAPE

8

With a detail grip, work on rendering the text. Define bold and regular text on the pages.

TIP　Be careful not to get into too much detail when representing the text.

Drawing Hard and Soft Surfaces　　65

Hard & Soft Objects

Apple Tart

Here is a slice of a freshly made apple tart. Observe the bumps of the apple and the glaze, and then the crust. When you are attempting to quickly sketch this, you only need two pencils. For the pie, use the B pencil, and use the F pencil for the plate.

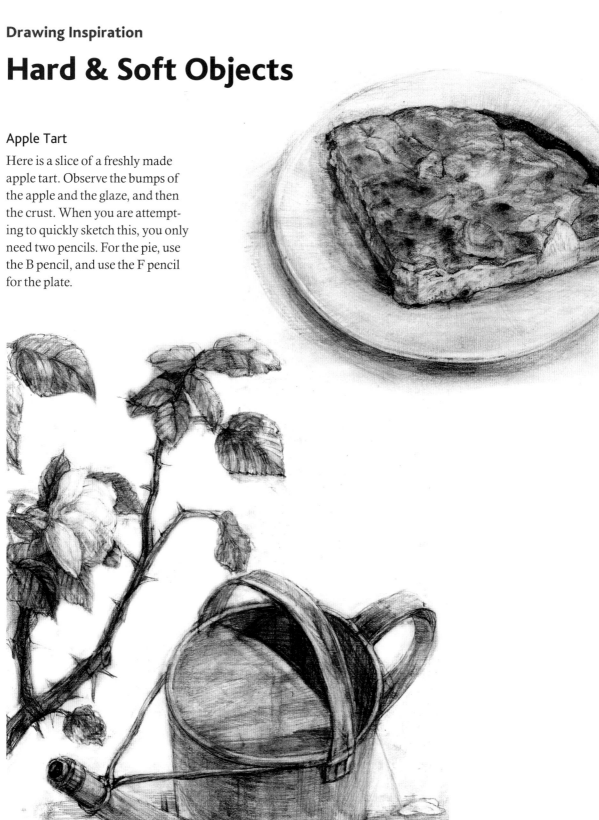

Roses and Watering Can

In this example, there are a variety of textures and colors to work with. For the watering can, use a hard pencil such as the H pencils. Observe the lines and curves of the rose stems closely as you work on the drawing.

Towel and Kitchen Cloth

Here is a plain towel with a cloth with checks. Practice illustrating the contrast of the jumbled towel on top of the carefully folded cloth.

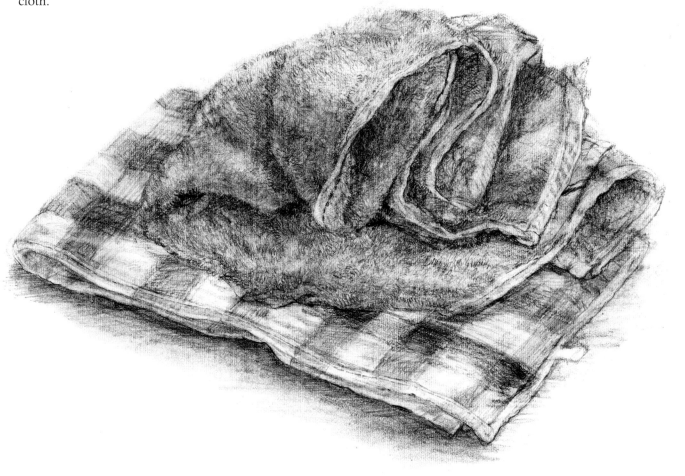

Electrical Outlet and Cords

With its detailed parts, and the different shades of gray, this is another good subject to practice drawing a variety of textures and colors.

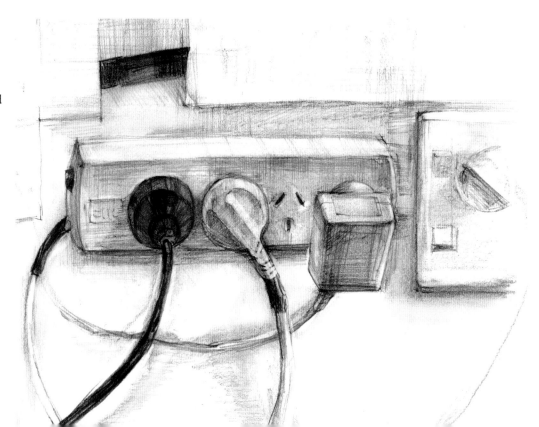

Lesson 9

Water Droplets

The look of transparency is created by manipulating the way light interacts with an object. Let's draw sparkling water droplets.

Photo example

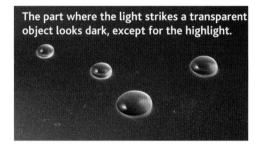

The part where the light strikes a transparent object looks dark, except for the highlight.

Basics to apply (pages 26–35)

[LIGHTING] [SHAPE] [TEXTURE]

Water droplets and glass are transparent. If you observe transparent objects carefully, you will notice that the lighting is reversed. It is darker where the light falls, and brighter on the opposite end—the reflected light. Starting with water droplets will ease you into drawing transparent objects.

Completed drawing

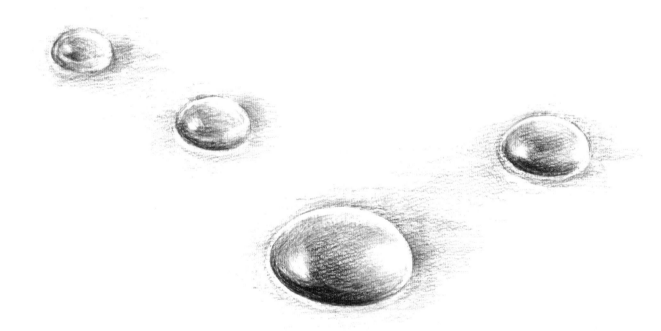

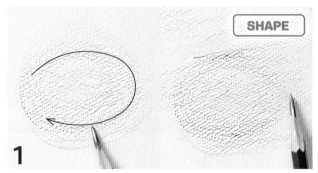

[SHAPE]

1

Sketch out the circular outlines of your water droplets, and begin to lightly add the shadows.

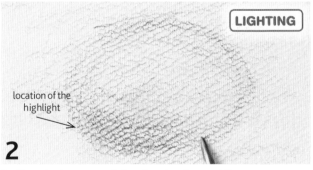

[LIGHTING]

location of the highlight

2

Define the bottom of the droplet (page 41).

(TIP) The dark part here is the part facing the light source.

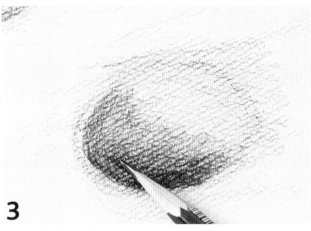

3

Shade in the dark area.

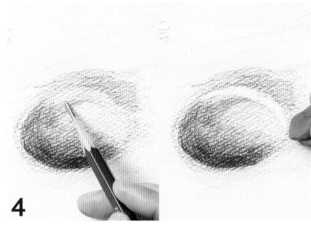

4

Shade in around the droplet as needed, and don't forget the shadow behind the droplet. Use the eraser to define the edge between the water droplet and its shadow.

TIP The lighting is counterintuitively reversed.

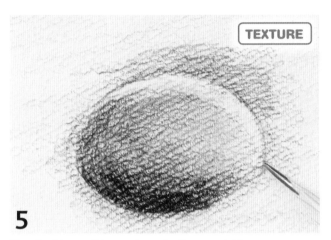

TEXTURE

5

Use the H pencil to work on further gradation.

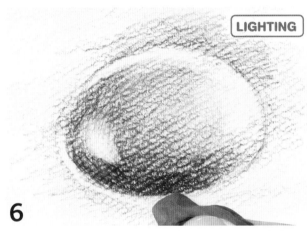

LIGHTING

6

Here is the important part. Use the eraser to highlight the shiny part where the light hits the water droplet.

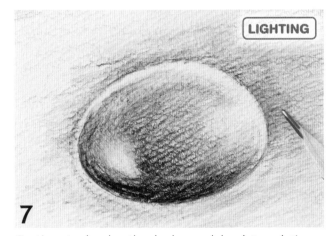

LIGHTING

7

Continue to develop the shadow and droplet gradation.

TIP The shadow is important for defining the light part of the droplet, so work on it carefully.

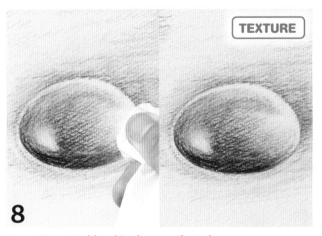

TEXTURE

8

Use a tissue to blend in the pencil strokes as necessary.

Lesson 10

Glass

For the drinking glass, you must be able to accurately draw the cylinder and light contrast.

Photo example

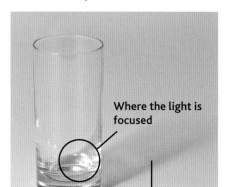

Where the light is focused

A shadow is necessary

Completed drawing

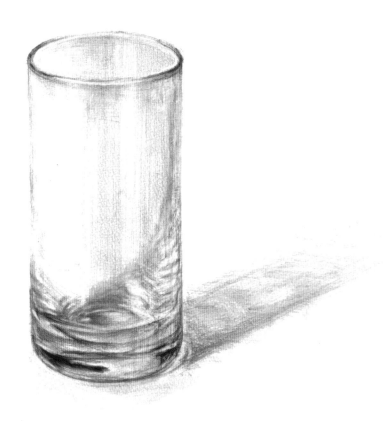

Basics to apply (pages 26–35)

LIGHTING · SHAPE · TEXTURE

The glass is shaped differently from the water droplet (page 68), so the light bends differently. It is rather the opposite from the formula presented in the preceding droplet lesson. You will need a lot of help from the kneaded eraser to express the shadows and light.

SHAPE

1

Measure and sketch out the cylinder shape. Use the B pencil during this process.

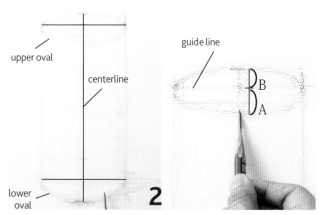

upper oval

centerline

guide line

B
A

lower oval

2

Make sure you get the perspective right and remember that the top and bottom ovals are different in size. Make sure to measure the object accurately.

TIP By the rules of perspective, the B portion of the curve is narrower than the A portion of the curve.

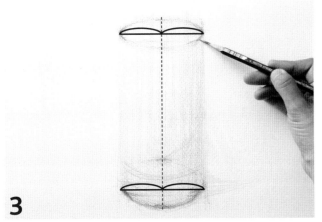

3

Follow the same steps with the top and bottom ovals and define the top rim and bottom part of the glass.

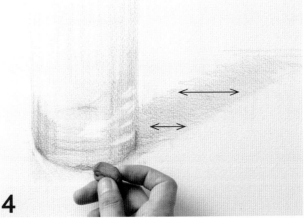

4

Create a realistic shadow behind the glass.

TIP Think of the shadow as being part of the object.

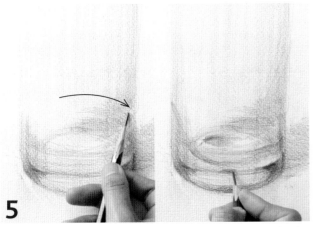

5

Define the bottom circle. Once the shape is established, use an HB or F pencil to work on the areas of contrast.

TIP Make sure you create strong contrast on the thick base of the glass.

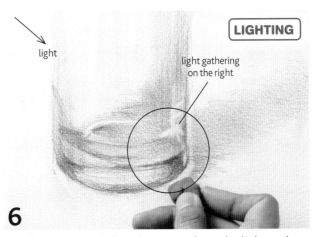

LIGHTING

light

light gathering on the right

6

Use the eraser to define the areas where the light gathers.

TIP The light is coming in from the left, so the light gathers and reflects from the right.

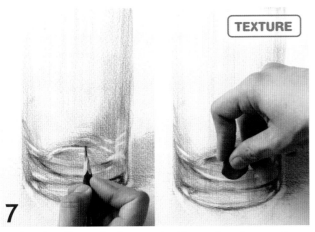

TEXTURE

7

With a detail pencil grip, use the H pencil and eraser to work on the gradation.

TIP The contrast expresses the composition of the glass.

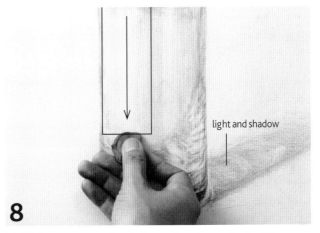

light and shadow

8

Hold the eraser horizontally and make vertical white streaks with gentle strokes.

Transparent Objects

Faceted Glass

For crystal or glass with multiple cuts or facets, you can see the angled light going through the glass. Here, you must plan out the cut angles very well, otherwise you could end up with a mess. Express contrast in the gradation.

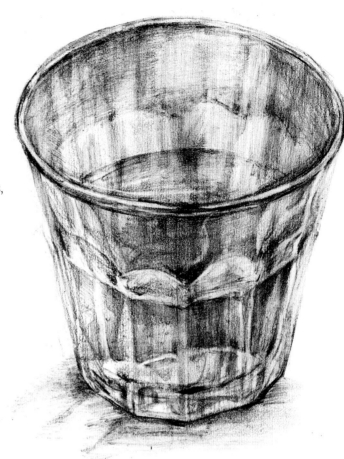

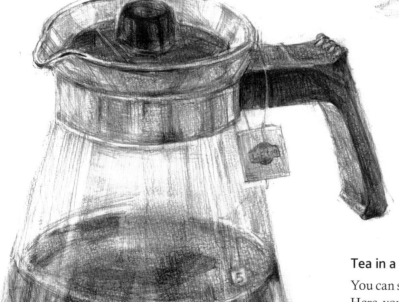

Tea in a Carafe

You can see through the dark liquid. Here, you can work with multiple levels of transparency and contrast.

Package of Dried Fish

With the dried fish visible through the package, you will get to work on portraying contrasting textures through a transparent surface. The contents of the package become blurrier the deeper it is. You can clarify the contents of the package by leaving one fish outside of the wrapper.

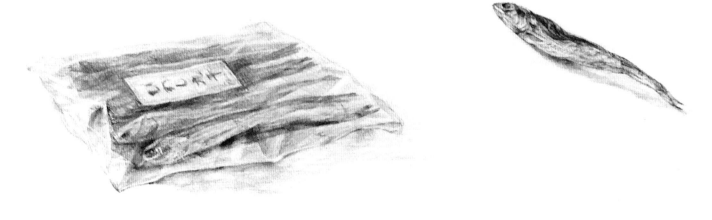

Lemon in a Glass Container

This is an example where you will develop multiple layers of texture and transparency. There is the surface of the lemon inside the water, as well as above the water. The water inside the clear glass container makes this drawing look amazing.

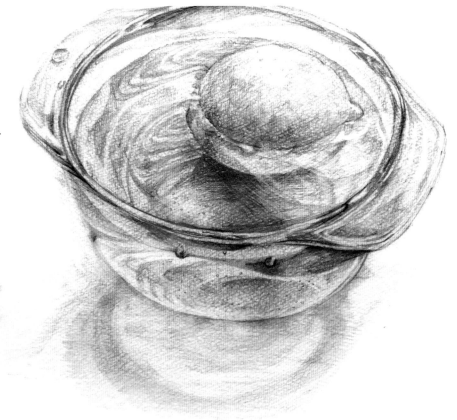

What to Observe When Drawing

Is there a difference between your drawing and the appearance of the actual object? If you can recognize the issues, you can work to improve your drawings.

Understand the basic structure of things

Do you understand the basic structure of the object? In order to do so, it is important to understand the basic components of the shape, and to be able to depict how light, shadows and reflected light define the shape. If you're struggling with this, go back to "Understand the Five Basic Techniques" (pages 26–35) and review. Even if you've mastered the basics of this kind of drawing, you may still occasionally struggle to grasp the basic structure of objects. But you cannot address what you don't understand, so persevere!

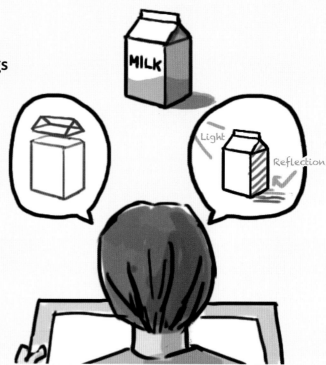

Mistakes will happen

Even if you've studied drawing for years, mistakes are bound to happen. Drawing is largely a mental activity that involves a lot of subjective judgment. Also, it is tempting to wrap up a drawing without correcting its flaws, and so it takes a certain amount of self discipline to correct drawing mistakes before moving on to the next drawing.

It is important to be objective

If you're lax in checking for mistakes, you may not notice a problem (or pretend not to notice!). Try the following methods to eliminate overlooking mistakes. These will help you to look objectively.

How to find mistakes

View the drawing upside down

View the drawing in the mirror

View by squinting

Measure with pencils

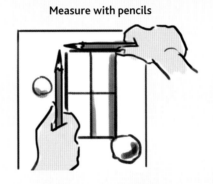

Avoiding self-sabotage

Even if you intend to look objectively, the mind has a way of manufacturing its own blind spots. If you find this happening to you, give yourself some time before returning to the drawing, or ask other people for their opinions. Don't be too shy to ask, "What do you think about this drawing?" Make sure you ask for a frank opinion. The joy of correcting mistakes and improving your ability to draw realistically is its own reward.

(TIP) Things to try

Take a break

If you are feeling fried after a long drawing session, or you feel like you're too familiar with the work to see its flaws, have a cup of tea, sleep on it, or try other relaxation strategies to refresh your mind.

Ask people

Some people prefer to work through artistic difficulties on their own rather than consult with others, but even after you become an accomplished artist, you'll find that the perspectives of independent observers can be invaluable.

Know your weaknesses

We all have weaknesses, but sometimes we're not aware of them. For example, someone may always start a drawing at the top, or their vertical lines may all skew to the left. Problems may be exacerbated by poor posture or uncorrected vision. When you understand your shortcomings, you can actively work to address them.

Lesson 11

Piece of Squash

Select a large slice to work on. Let's work on depicting light as it falls on different surfaces.

Photo example

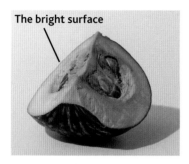

The bright surface

Completed drawing

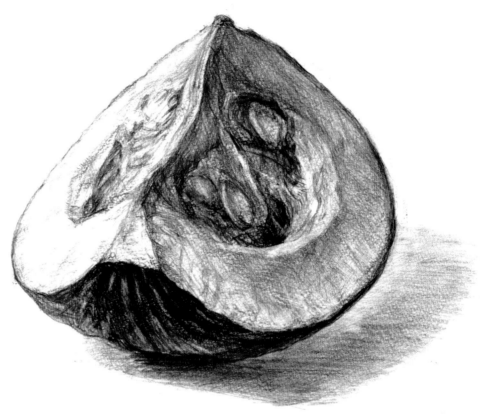

Basics to apply (pages 26–35)

POSITION | SHAPE

LIGHTING | TEXTURE

It is good to clearly show both the interior and exterior of the squash. Maintain a good sense of balance in the entire composition. Observe the light and shadows very closely, as well as the contrasting colors of the flesh and skin.

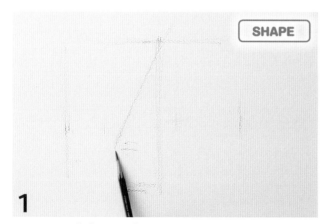

SHAPE

1 Measure and plot out the various points and their relationships. Sketch with a B pencil.

TIP Avoid positioning the object facing straight on, because you will end up with an uninteresting image.

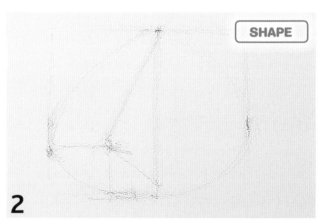

SHAPE

2 After mapping out the points, lightly sketch out the shape.

TIP Make sure you confirm where all the points meet when you draw in the outline.

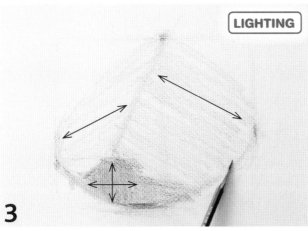

LIGHTING

3

Shade each of the surfaces, keeping the colors and lighting in mind.

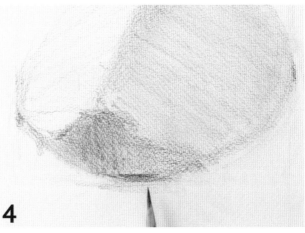

4

Define the bottom of the object (page 41).

TIP Try not to overdo it with the shadows. If you do, your drawing might start to look lopsided.

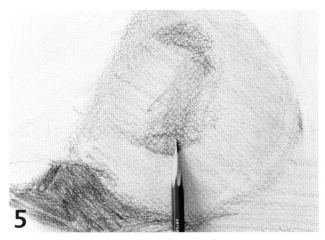

5

Start to shade in the core of the squash.

TIP Don't begin working on the seed details yet.

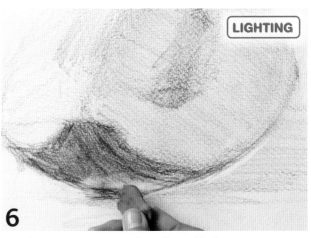

LIGHTING

6

Use the eraser to create the reflected light.

TIP Be careful not to erase too much here. Add the reflection gradually, keeping it subtle.

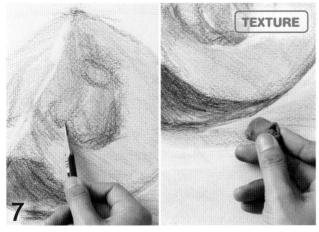

TEXTURE

7

Start working on the seeds in detail. Use a soft B pencil to work on the skin. Use the eraser to fix the shadows.

TIP The skin is dark, but shiny and mottled—so there should be parts that look quite light.

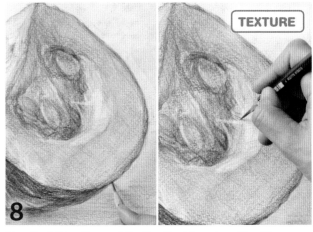

TEXTURE

8

Use the HB or F pencil for the final touches. Use the eraser to work on the skin, to show the bumpy texture. With a detail grip on the pencil, finish the details all over.

Lesson 12

Sunflower

There are lovely contrasting textures going on in this drawing. The blossom is nice and large.

Photo example

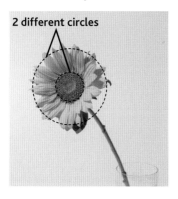

2 different circles

Completed drawing

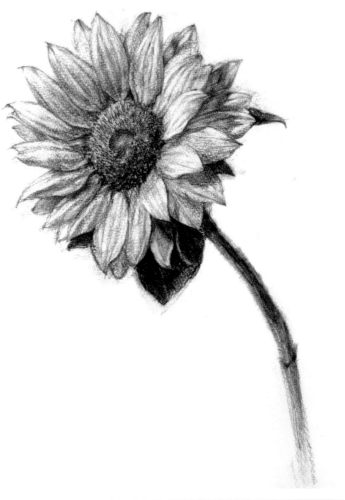

Basics to apply (pages 26–35)

LIGHTING SHAPE

TEXTURE SPACING

First, draw a large outer circle, then draw in the central circle, a portion of the stem, and then the petals. Do not draw the petals one by one. Instead, divide them into four equal parts and draw them all at once. Draw the petals and leaves with an HB or F pencil.

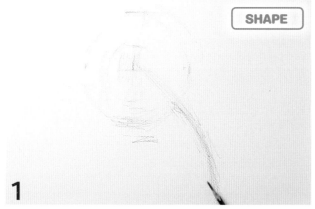

SHAPE

1

While measuring the shape, start to define the central circle, and the rough shape of the petals and the stem. Use a soft B pencil for this.

TIP It is a natural object so you don't have to be too stuck on creating the shape. Just be careful with the shapes of petals and position of the leaves.

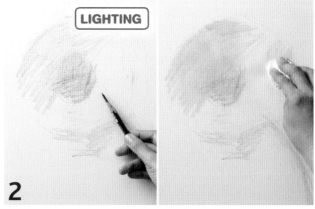

LIGHTING

2

Make a large shadow where the petals will go and blend it with a tissue.

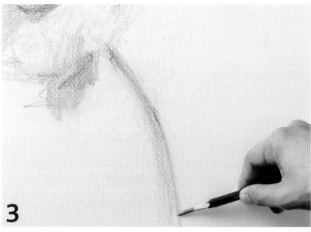

3

Loosely sketch the leaves in the front. Draw a curve while remembering that the stem is cylindrical—you don't want it to appear flat.

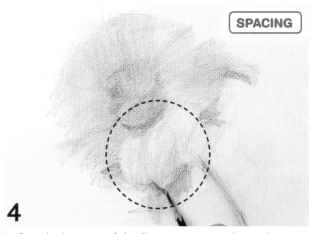

4

Define the bottom of the flower to create the anchor point.

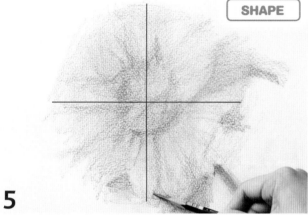

SHAPE

5

Divide the petals into quadrants. Don't draw the petals individually. Instead, draw them all at once in each quadrant.

TIP Don't draw the petals individually.

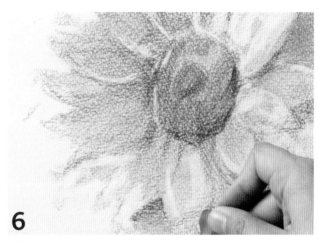

6

While completing each quadrant, work on the contrast and definition between the petals with the help of the eraser.

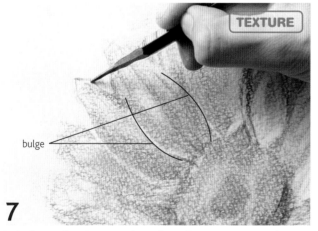

TEXTURE

bulge

7

Switch to a harder pencil, such as the HB or F pencils. Work on the accents with the detail grip.

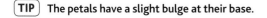

TIP The petals have a slight bulge at their base.

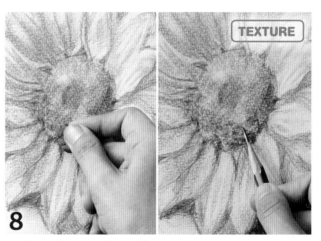

TEXTURE

8

Work on the central seed-bearing areas. Work on the texture all around until you're satisfied with the look of it.

Complicated Shapes

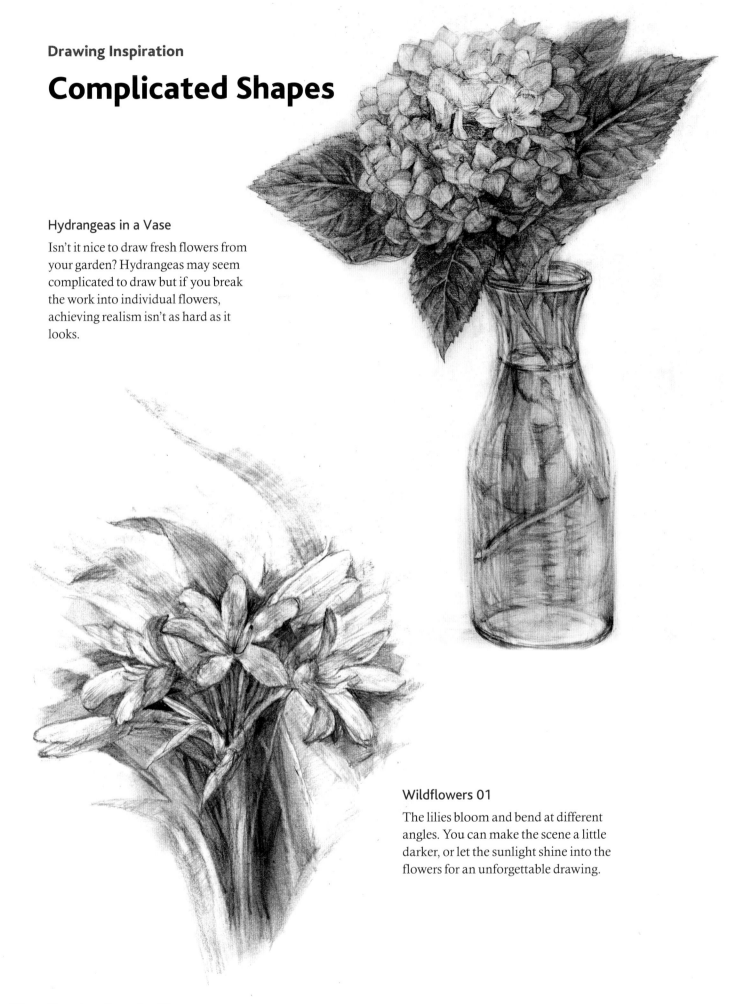

Hydrangeas in a Vase

Isn't it nice to draw fresh flowers from your garden? Hydrangeas may seem complicated to draw but if you break the work into individual flowers, achieving realism isn't as hard as it looks.

Wildflowers 01

The lilies bloom and bend at different angles. You can make the scene a little darker, or let the sunlight shine into the flowers for an unforgettable drawing.

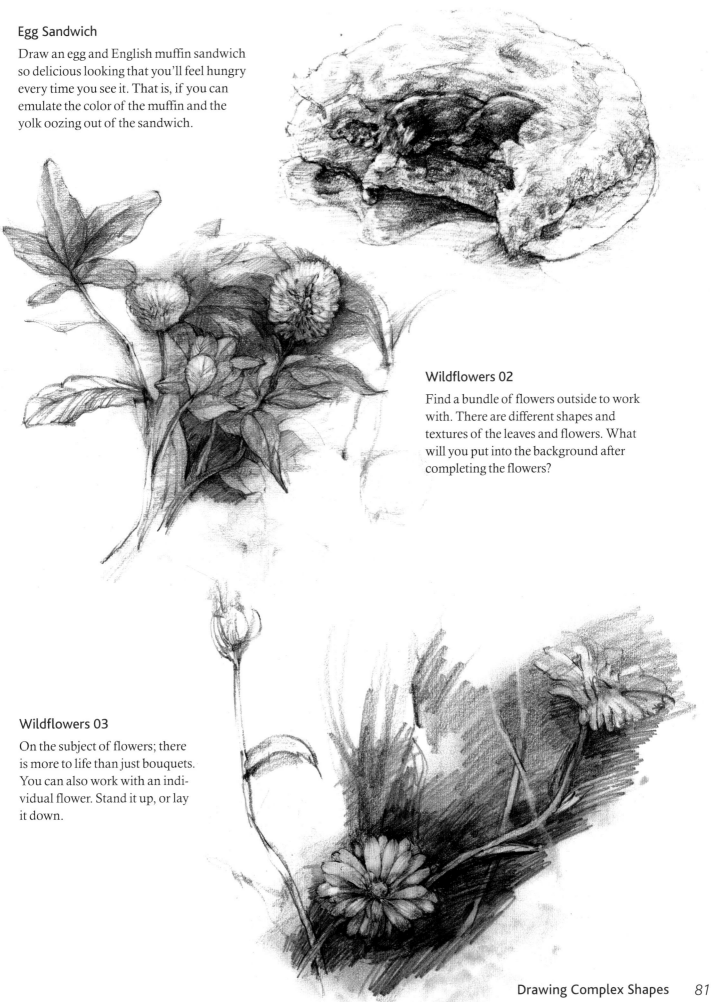

Egg Sandwich

Draw an egg and English muffin sandwich so delicious looking that you'll feel hungry every time you see it. That is, if you can emulate the color of the muffin and the yolk oozing out of the sandwich.

Wildflowers 02

Find a bundle of flowers outside to work with. There are different shapes and textures of the leaves and flowers. What will you put into the background after completing the flowers?

Wildflowers 03

On the subject of flowers; there is more to life than just bouquets. You can also work with an individual flower. Stand it up, or lay it down.

Portraits vs. Generic Drawings

If you are drawing a person, you will want your representation to be realistic. However, be careful not to allow your drawing to become idealized portrayals of the subject, or worse yet, caricatures. So what should we be mindful of when drawing people?

Portraits are different than generic drawings of people

Think of a portrait as something you draw to look intrinsically like your subject—it is more than just drawing a generic person with features somewhat tailored to your subject. When you start by drawing a generic person, it's easy to fail to observe your subject very keenly. However, to capture the essence of your subject, you must forget that you are drawing a face or body, and concentrate on breaking the form into its constituent three-dimensional components. Discard the goal to simply draw a person with features similar to your subject, and focus on really observing your subject to capture their true likeness.

Somehow, it's different than what I expected.

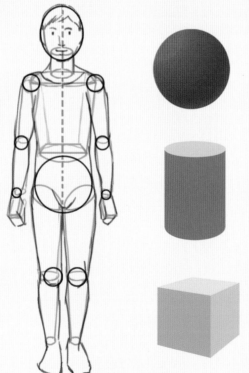

It is important to understand the three-dimensional structure of the person

The first step is to understand the three-dimensional structure of the person and check the light source. While you're at it, envision the texture of each surface to be drawn. Even if you've never studied human anatomy, you can still capture the essence of each part. The head is basically a sphere, the arms are cylinders, and the body is a cube or cylinder. You can also use your own body as a model.

Take stock of your entire subject

When drawing a person, you tend to focus on drawing faces rather than the body or hands. But once you master drawing faces, consider pulling back to also show the hands and body. When doing this, it's important to take time to observe the entire person.

Get a sense of a person's presence

It's appealing to make a drawing of a full person because you can capture the unique presence of the individual by portraying their entire body. For example, if a close friend or relative walks toward you from a reasonable distance, you may not be able to see their face clearly, but he or she may be identified by how they carry themselves. To see how professional artists inject this singular sense of life and personality into their work, take time to look at many examples, including the paintings of famous painters. The reason for the enduring popularity of these master works is the way the artists have captured the essence of their subjects.

Lesson 13

Hand

Bend your fingers or otherwise capture a dynamic pose for this drawing.

Photo example

2 different cylinders

Basics to apply (pages 26–35)

POSITION SHAPE

LIGHTING TEXTURE

Observe the hand carefully and determine which parts will be visible in the drawing. Instead of drawing one finger at a time, sketch the combined shapes of the wrist, palm and mass of fingers all together. Be aware that the fingers are essentially cylindrical. Use a tissue and B type pencil to develop soft textures.

Completed drawing

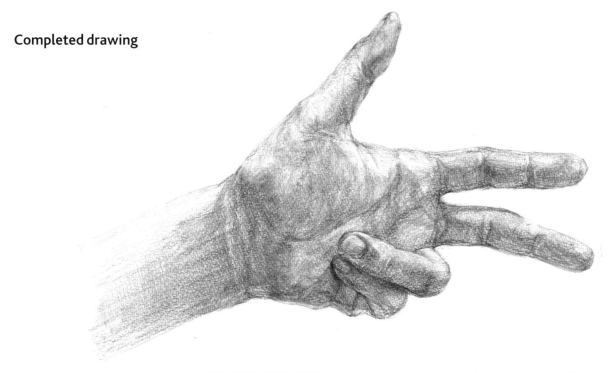

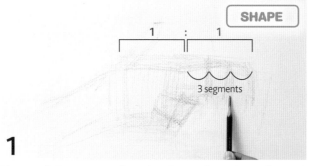

SHAPE

1 : 1

3 segments

1

Use a soft B type pencil to sketch out the wrist, palm and fingers in one mass.

TIP Notice that there is a 1:1 ratio between the palm and fingers. Split the fingers into three segments. Do not fine tune one finger at a time, but slowly refine them all together.

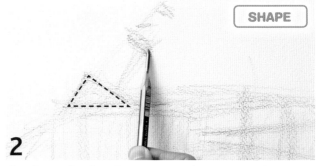

SHAPE

2

Sketch out the thumb. Be sure to place it properly so that the four fingers end up facing in the right direction. Rough in the shape of the triangular part of the thumb's root.

SHAPE

3

Start sketching out the ring finger and the pinky. The end of the pinky is angled toward the end of the ring finger.

LIGHTING

4

Add a large shadow and blend it with a tissue.

TIP Because the skin is not shiny, the highlight does not become white even when strongly lit. Lightly shade in the brighter parts.

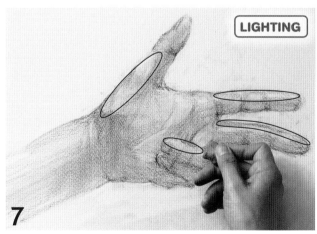

5

Blend in the darkest part of the hand.

TEXTURE

6

Use the eraser to work on the creases and lightly darken the deeper parts with a pencil.

TIP You can achieve a soft texture with the eraser.

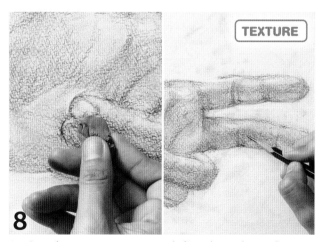

LIGHTING

7

While considering the direction of the light source, use the eraser to make accents where the skin is illuminated.

TIP Note that if you make the bright circles too pronounced, those parts will appear to be projecting forward.

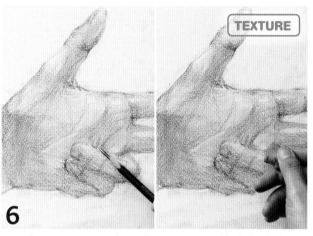

TEXTURE

8

Again, take out your eraser to define the nails. With a detail grip, define borders between areas of light and shadow. Continue to refine the drawing until you are satisfied with it.

Lesson **14**

Face

To draw faces, position yourself directly in the front of your subject. For a self-portrait, it may be difficult to get this perspective.

Photo example

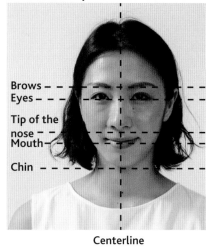

Brows – – –
Eyes – – –
Tip of the
nose
Mouth –
Chin – – –

Centerline

Completed drawing

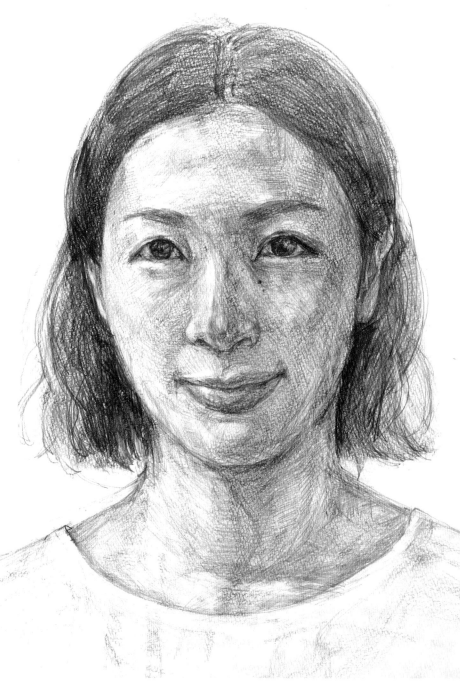

Basics to apply (pages 26–35)

LIGHTING SHAPE TEXTURE

Draw the centerline on the face, but be aware that human faces are not completely symmetrical. Instead of drawing the details of the face all at once, draw horizontal guide lines for the eyes, nose, mouth and chin. The shape of the head is basically spherical. Be aware of the facial bones and the way the face changes along with the bone structure.

centerline

1

Draw the center line. Use a B type pencil to begin to define the head and chin.

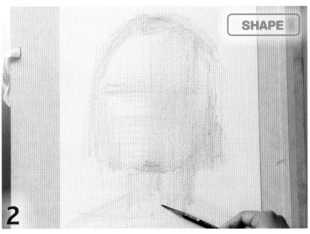

2

Once you define the left and right sides of the face, define the neck. Don't get into too much detail.

TIP If it is difficult to measure the face, squint your eyes to better comprehend the shape. This is another way to ascertain the general shape of your subject's face.

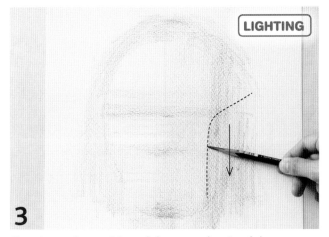

LIGHTING

3

Sketch out the position of the eyes, the tip of the nose and then the mouth. Shade to reflect the bone structure.

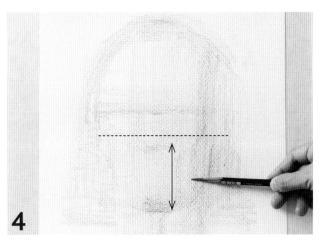

4

Shade in under the cheekbones.

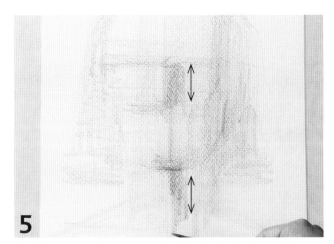

5

Shade next to the nose, and add a dark shadow under the chin.

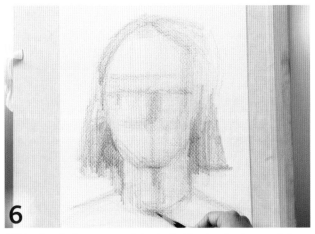

6

Fill in the darkest part of the hair. The basic shape of the neck is cylindrical.

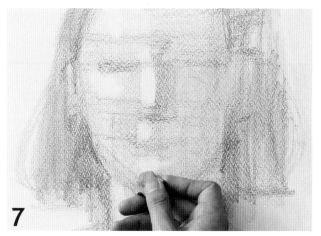

7

Highlight the nose with the eraser.

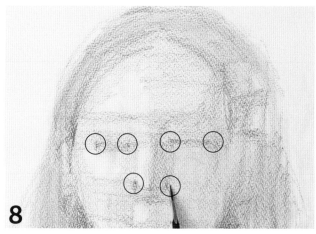

8

Start to mark the ends, left and right, of the nostrils and eyes.

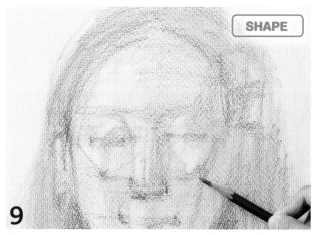

SHAPE

9

Divide the regions of the face into small areas of concentration.

TIP Be aware of where the faces changes to conform to the underlying bone structure.

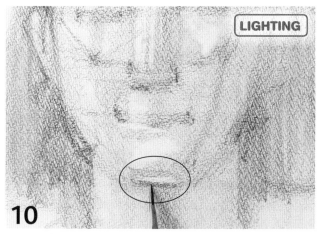

LIGHTING

10

Create the reflected light under the chin with the eraser and define the bottom with a dark shadow.

TIP Three-dimensionality is emphasized through reflected light.

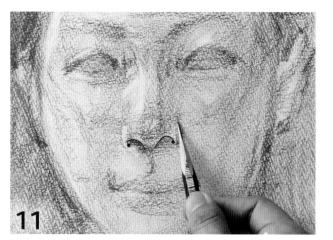

11

Use the HB or F pencil to draw in the nostrils.

TIP The nostrils are defined by partial oval shapes.

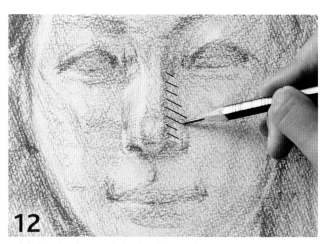

12

Add the shadows of the bridge of the nose.

13

Darken the border between the upper and lower lips, and add the reflected light of the upper lip.

> **TIP** Use lines of varying pressure to keep your drawing from looking like an illustration.

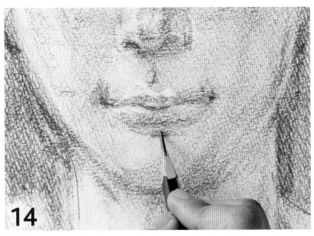

14

With the pencil, darken the lips to simulate their color, and shade in under the lower lip.

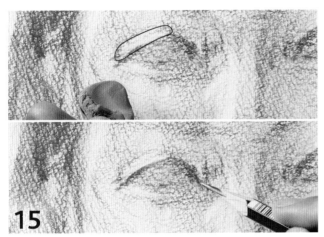

15

Use the eraser to mark the brightest parts around the eyes, and use the pencil to create contrast.

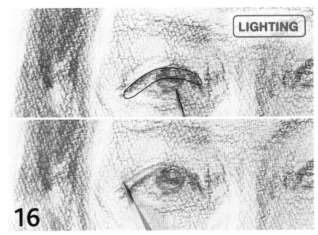

LIGHTING

16

Draw in the shadows of the eyelids, and in the corners of the eyes. Define the fold of the eyelid.

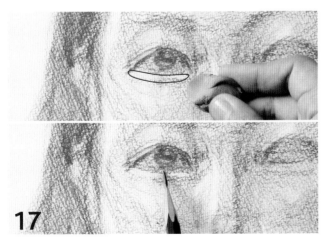

17

Use the eraser to emphasize the lower lid of the eyes, and define the edges of the lower lid with your HB or F pencil.

> **TIP** If you carefully address all of the details, the eyes will really seem to come to life.

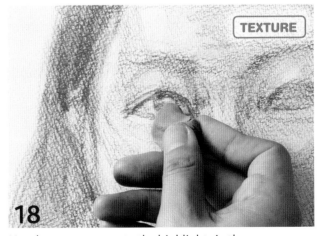

TEXTURE

18

Use the eraser to create the highlights in the eyes.

> **TIP** This finishing step defines the look of the eyes.

Lesson **15**

Upper Body Portrait

If your model wears simpler and more revealing clothing, it will be easier to observe their bone structure.

Photo example

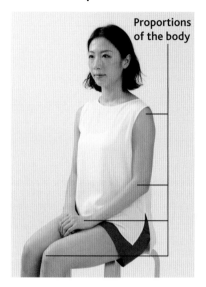

Proportions of the body

Completed drawing

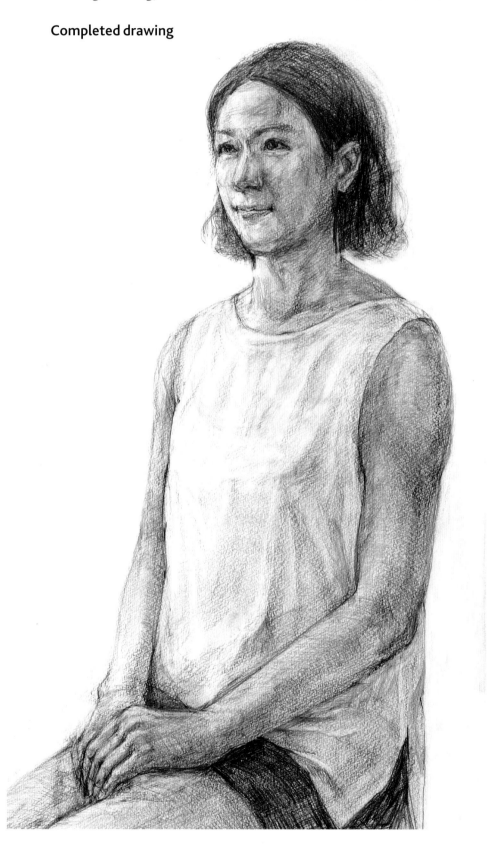

Basics to apply (pages 26–35)

POSITION TEXTURE

SHAPE SPACING

Ensure that your eye level remains consistent while working on framing your drawing (page 56). In this example, I end the drawing at the thighs, so the drawing is limited to the upper body. Rest the hands one on top of the other, so you can focus on drawing the face and hands. However, don't overwork the details of the face. Develop the sketch in sections, and proceed gradually through the drawing. It is a major exercise to draw most of the body. I recommend that you start with the upper torso.

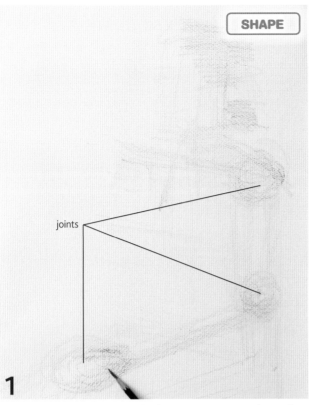

SHAPE

joints

1

Map out the shape and underlying structure with a soft B pencil.

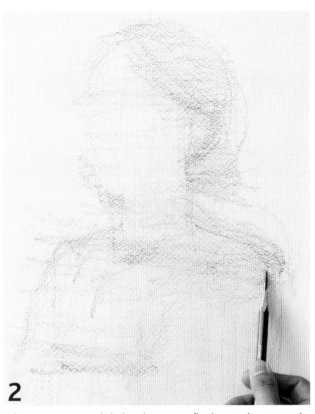

2

Observe your model closely as you flesh out the general shape.

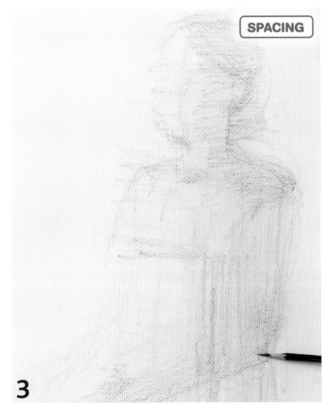

SPACING

3

Add the shadows of the forearm.

TIP Instead of shading in each part in a series, move all around the drawing to establish the overall light and shadows.

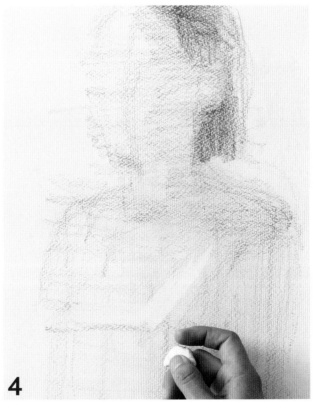

4

Start to shade the darkest parts such as the hair. Use the eraser to add highlights to the chest area.

Drawing Human Anatomical Features *91*

5

Start defining the shape of the fingers.

> **TIP** Work on the entire hand instead of focusing on only one finger at a time.

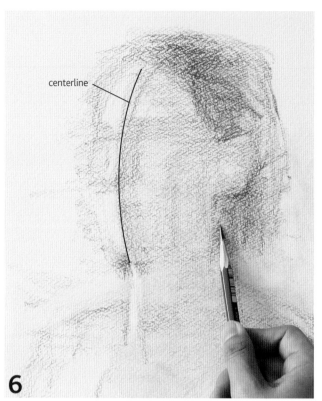

centerline

6

Draw the centerline on the face and mark the chin position first. Adjust the shape of the ear and neck.

> **TIP** The neck is cylindrical and relatively thick. Start from the base of the neck and work your way up.

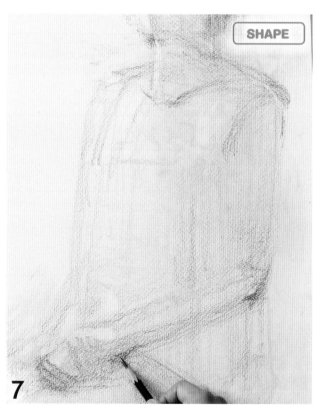

SHAPE

7

Position the hands and arms while being conscious of the joints of the shoulders, elbows and wrists.

> **TIP** Don't overwork the face. Draw the hands and clothes, and move along the whole body evenly. If you concentrate too much on one part it will stand out and appear strange.

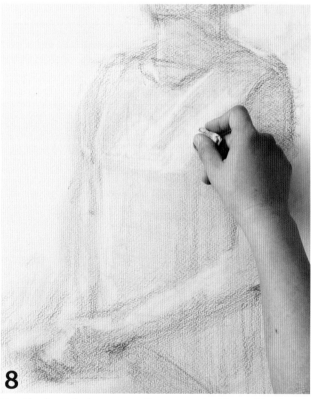

8

Use the kneaded eraser as if you are stroking with a brush to create a soft texture. Switch to an H pencil to work on the contrasting details after that.

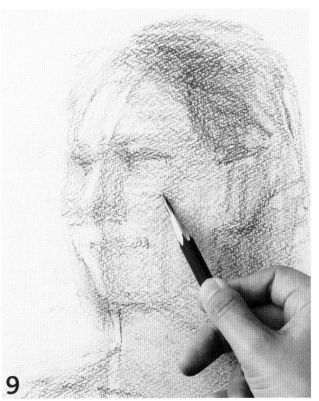

9

Gradually refine on the face. Measure the distances between the eyes, ears, nose and jaw (page 97).

TIP Use a well-sharpened pencil to work on the details.

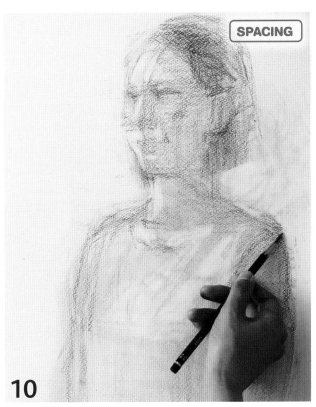

SPACING

10

Adjust the shading gradually from the front to the back.

TIP Be aware that the nearer shoulder should appear sharper, and the parts of the drawing farthest from the viewer will be softly blurred.

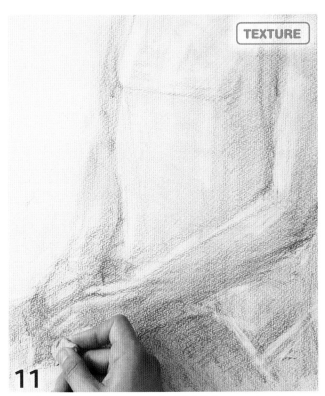

TEXTURE

11

Use the eraser to bring out the highlights on the clothes, arms and fingers. Bring out the soft textures of these parts.

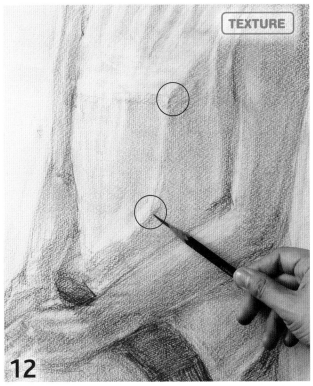

TEXTURE

12

Add highlights and shadows to the clothes, and don't neglect the difference in texture between skin and clothes. Continue refining the entire drawing until it is completed.

TIP The shadows are darker where the clothing drapes and folds.

Drawing Human Anatomical Features 93

People

Hands

Once you become adept at drawing hands, your portrait drawings become exponentially more realistic. You can practice sketching your own hand by simply holding it up as you draw with the other hand. You can also hold something to make the drawing more interesting and challenging. The first step is to get the muscles and creases just right.

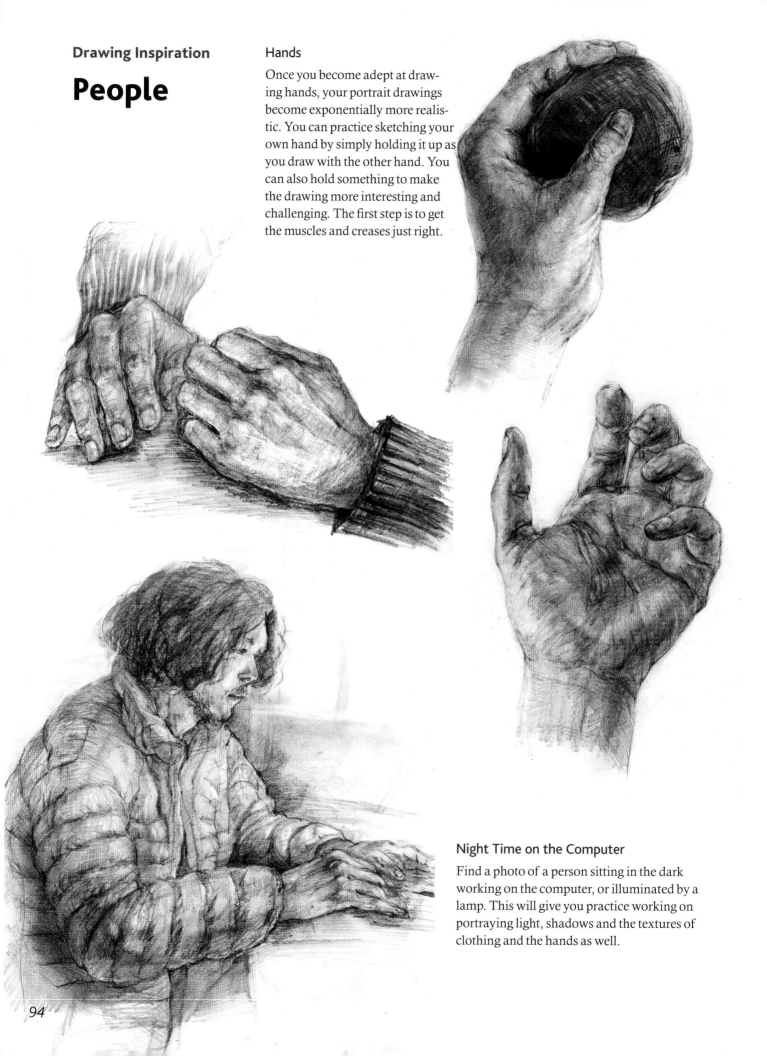

Night Time on the Computer

Find a photo of a person sitting in the dark working on the computer, or illuminated by a lamp. This will give you practice working on portraying light, shadows and the textures of clothing and the hands as well.

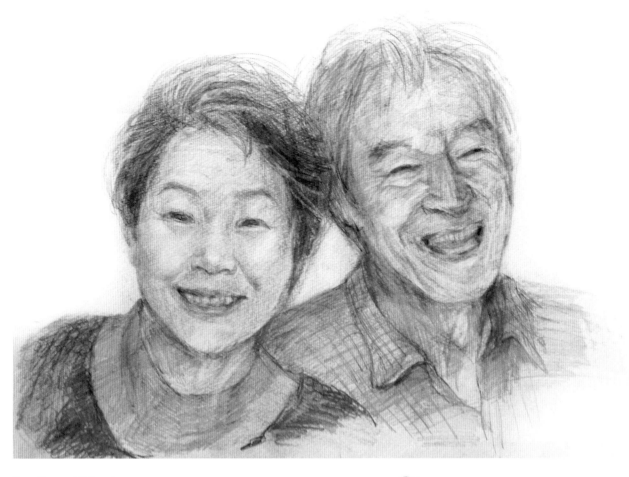

Family and Friends

It is a good idea to practice drawing your family and friends. Find a picture that is suitable and attempt a sketch. Because of your familiarity with the subjects, you will be able to notice right away if something is off. You will become increasingly adept at identifying problems in portraits of your loved ones.

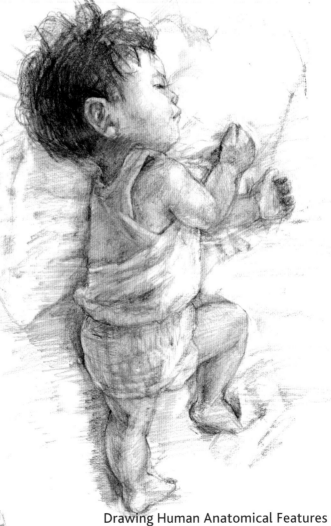

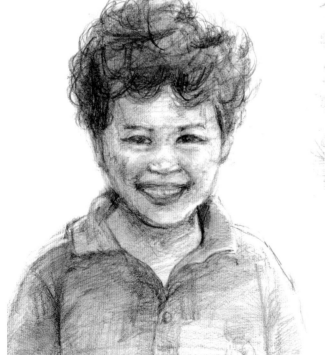

Draw Young and Old People

Age and gender differences will create a wide spectrum of distinctions in your drawings. Let's review the relevant information.

The composition changes by age

As people age, their bodies change, and their facial proportions also change. The facial features of a baby occupy the lower half of the head. As a child grows into adolescence, the face stretches and the features appear to be centered. As people grow into adulthood, the facial features rise on the face.

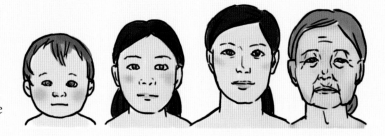

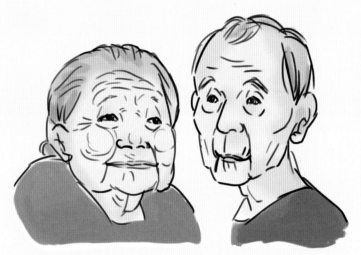

As you get older, wrinkles appear

The skeletal structure of the face is set once we become adults, but as time goes by, the skin gets wrinkled as it loses elasticity. The appearance of advanced age changes depending on what kind of wrinkles appear and how they are drawn.

> **TIP Apply what you know to cartooning**
>
> You can create cute cartoon characters by manipulating their apparent age. For example, if you want to make a cute character for kids, you can make it look adorable by making the facial proportions close to those of an infant's.

Differences between men and women

There are obviously differences to draw depending on gender. In general, men and women are about 7½ heads high. Let's look at some of the typical contrasting details.

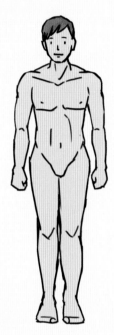

Typical fit male
● Boxy build
● The shoulders and legs are large and strong
● Adam's apple may be visible in the throat

Typical fit female
● Relatively curvaceous
● Fuller chest and wider hips
● Narrower waist

Handy body proportion reference

Save yourself a lot of frustration by keeping the body proportion rules of thumb (see right) and age & gender attributes (opposite and above) in mind as you draw portraits. Here are some proportion tips:

- The bottom of the nose and the bottoms of the ears are at the same level.
- The pupils and the tops of the ears are at the same level.
- The distance between the inside corners of the eyes is about the same as the width of an eye.

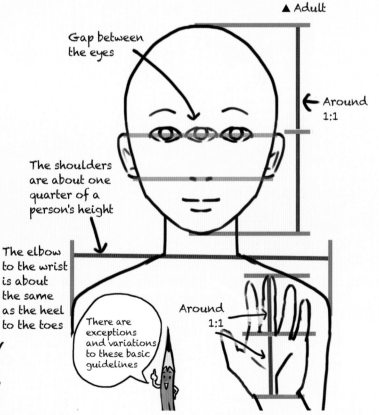

▲ Adult

Gap between the eyes

Around 1:1

The shoulders are about one quarter of a person's height

The elbow to the wrist is about the same as the heel to the toes

Around 1:1

There are exceptions and variations to these basic guidelines

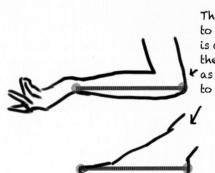

Lesson 16

Tree

Choose a tree with good amount of volume in the canopy. Leaves can be easily drawn in large clumps.

How to emulate colors with a pencil

A: Bright green (H, F)
B: Medium green (HB, B)
C: Dark green (H, HB, blending)
D: Deep brown (B, 2B, blending)
E: Brown with reflected light (B, blending)

Basics to apply (pages 26–35)

LIGHTING TEXTURE

SHAPE SPACING

Instead of drawing individual leaves and other fine details, start by working all over the drawing in large areas. The definition of the leaf clusters can be expressed by moving the pencil in various directions and drawing lines with varying amounts of pressure. The scene will look different depending on the light and the weather.

Completed drawing

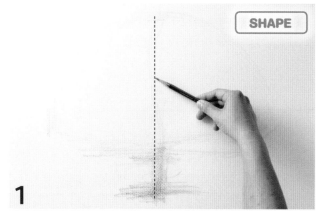

SHAPE

1 Measure the length and width while checking the proportions. Draw a centerline while sketching out the trunk.

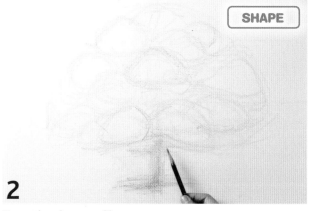

SHAPE

2 Draw the clumps of leaves.

TIP Avoid drawing the leaves in too much detail.

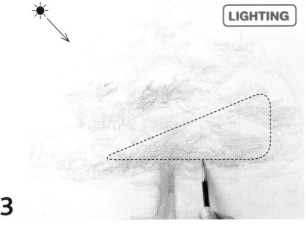

LIGHTING

3

Determine the direction that the light is falling, and then add shadows into each clump. In this case, the lower right portion of the tree boughs has more dark shadows.

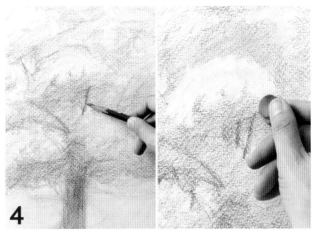

4

Start to add the branches in the gaps between the clumps. Use the eraser to add highlights to the branches.

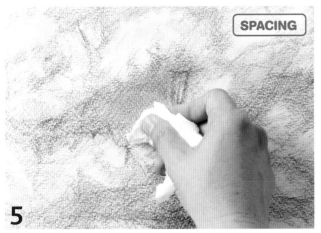

SPACING

5

Further define the shadows under the clumps of leaves with a B pencil and use a tissue to blend.

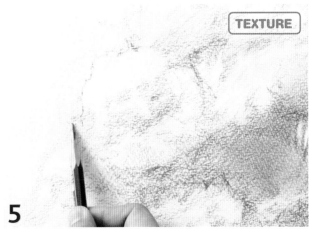

TEXTURE

5

Add an outline around each of the clumps you drew to give some definition to the leaves. This will give your drawing some texture.

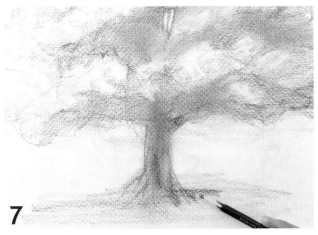

7

Work on the dark tones in the trunk. The trunk gets thicker as it nears the roots.

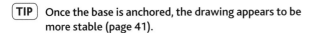

TIP Once the base is anchored, the drawing appears to be more stable (page 41).

TEXTURE

8

Continue to add texture to the clumps of leaves without going so far as to draw individual leaves. Work on the contrast and texture until you are satisfied with the drawing.

Lesson 17

Building

This drawing will test your knowledge of perspective. View from an elevated perspective for best results.

Perspective points

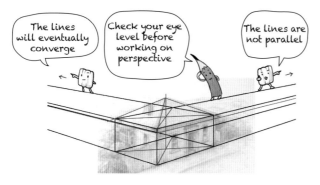

Basics to apply (pages 26–35)

POSITION SHAPE

LIGHTING SPACING

Avoid drawing the front of the house head on, and choose an angle that allows you to see the shape of the building. Assess the direction of the light, and then add the shadows. Remember the principles of perspective—particularly two-point perspective (page 57). Depth in the drawing is expressed by blurring out the details in the distance.

Completed drawing

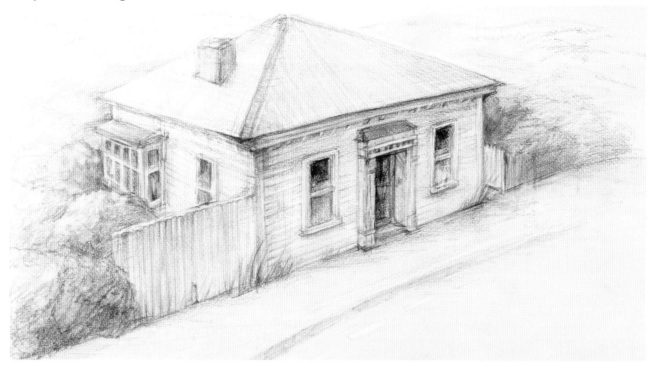

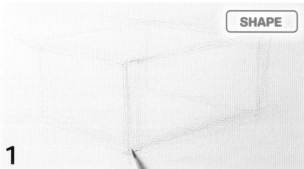

SHAPE

1

Sketch the house. Follow the principles of perspective.

TIP Allow the ends of your pencil strokes to go beyond the edge of the building.

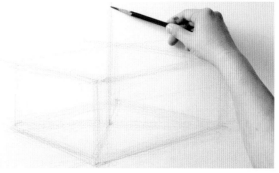

2

Draw diagonal lines from corner to corner at the base of the building. Extend a vertical line from the intersection of these lines to just above the walls of the building. The apex of the roof is now revealed.

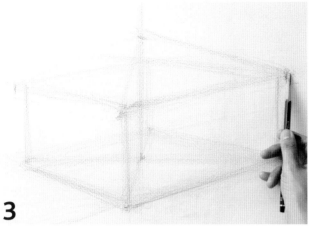

3

Use the centerline you created in step 2 to draw the lines of the roof structure.

[TIP] **The eaves of the roof should extend beyond the walls.**

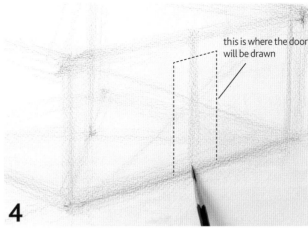

this is where the door will be drawn

4

As the entrance is at the center of the building, draw a diagonal line in the front "wall" rectangle to determine the center of that plane.

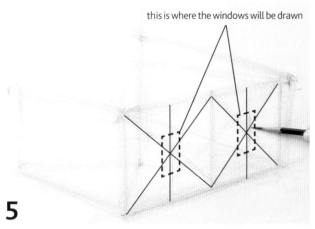

this is where the windows will be drawn

5

Draw diagonal lines across the two squares bisected by the line drawn in step 4 and draw vertical lines centered on the points of their intersection. This is to determine the location of the windows.

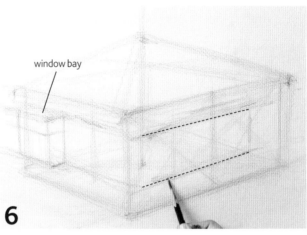

window bay

6

Determine the top and bottom edges of the door and windows.

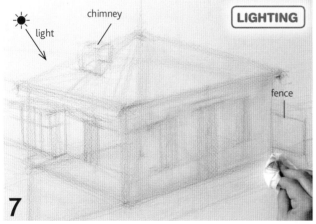

light

chimney

fence

LIGHTING

7

Once you position the chimney and the fence, blend out the guidelines and any overextending shading lines with a tissue.

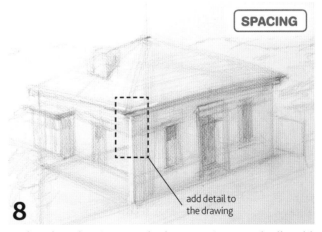

SPACING

add detail to the drawing

8

Rather than drawing one shadow at a time, gradually add the dark tones in horizontal strokes as you work around the drawing.

Landscapes

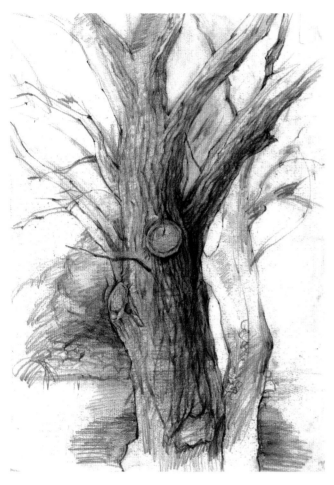

Trees

When you draw a big tree you can almost feel its presence reaching out to you from the drawing!

A Passing Car

Consider taking a field trip once in a while to draw a car that you're unfamiliar with. You can try to commit to memory your observation of a passing car, or take a photo if you prefer. Depending on your camera, you may be able to "see" the movement of the car in the form of motion blur.

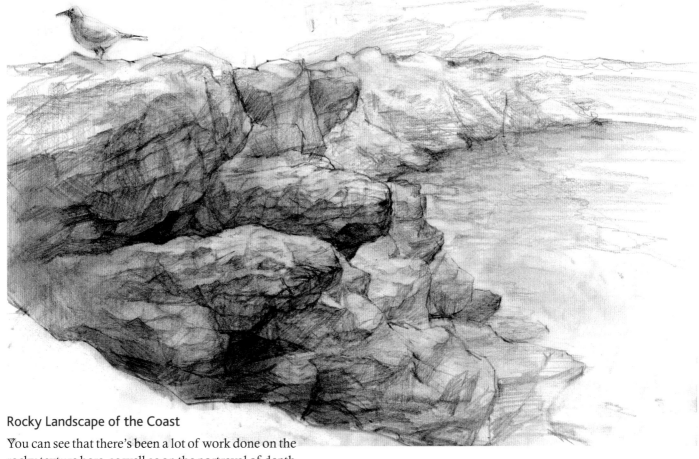

Rocky Landscape of the Coast

You can see that there's been a lot of work done on the
rocky texture here, as well as on the portrayal of depth.
There could be more contrast between stone and water.

Railway Landscape

Here is inspiration for an interesting land-
scape to work on that depicts a scene from
daily life. Trains and other man-made ob-
jects set against natural backdrops make
for exciting compositions.

Ship Docked in Port

Photos of ports also make for compelling imagery to draw.
You can position the ship in your drawing so that you are
able to see it partially from the side. There are a lot of inter-
esting details and different textures in this landscape.

Draw from Life—Not from Photos

Due to its permanency, photography seems like a natural choice to use as a reference when taking your time with a drawing. So why is it better to draw from life?

The real thing is better than a photograph

If you take art instruction, you may be told, "Look at the real thing, not a photo, when you draw." When you are just starting to draw, it is recommended that you draw from life. You need to be able to observe the object's structure in three dimensions in order to better comprehend its structure and setting. Also, if you draw from photos, it is difficult to accurately ascertain depth because the object is often uniformly in sharp focus, making it appear quite two dimensional.

But don't be afraid to use a photograph

Photo reference is useful when drawing subjects that are likely to move or change: cut flowers or fruit, clouds, animals, objects lit by natural light, etc. When taking a reference photo, carefully compose the scene as you would a drawing, considering how close or distant the subject should be. Focus the composition of the photo solely on the subject you intend to draw so you're close enough to capture it in sufficient detail. Take photos of the subject from various angles to better document its structure. In addition to photos, observe carefully and take notes about the subject's characteristics. If you have time to do so, it is also useful to make some quick sketches to increase your understanding of the subject's form (page 114).

Choose a picture of the object

Use photos of models

Photographs of models used in magazines and advertisements often show light that is cast and reflected from various directions to make them look evenly illuminated. Try to choose photos with light coming from one direction—it's difficult to create a three-dimensional effect when the light is diffuse.

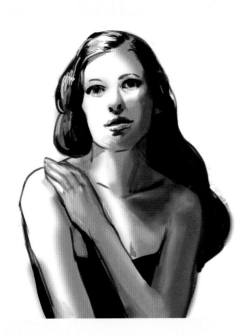

Useful landscape photos

Useful reference photos of landscapes should exhibit interesting perspectives, and an object that is the primary feature (people, vehicles, buildings, etc.). This will make it easier for you to depict engaging compositions.

Pointers for drawing while referring to photos

If possible, choose a photo that encompasses your entire subject. By being able to see the entire scene in the picture, it will be easier to detect distortions and irregularities. While drawing, try to imagine the three-dimensional form of your subject—a drawing tends to be rather lifeless if made by simply replicating the lines and tones of a photo without the artist also understanding the form of the subject. When you capture the reference photo, study the subject carefully, noting textures, colors, shadows, lighting and other attributes so you will be able to recall them later while you draw. This will improve your results.

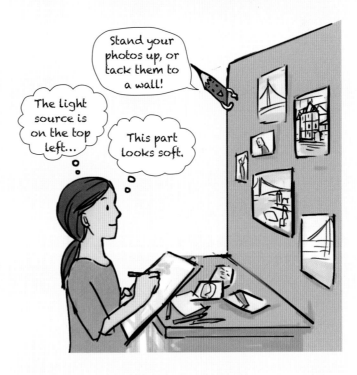

Lesson **18**

Cat

If you have a long-haired cat as your subject, it will be challenging to observe its bone structure. Let's draw a cat in a sitting pose.

Basics to apply (pages 26–35)

SHAPE TEXTURE

Carefully observe the form of the cat and note its underlying structure. Rough in the head, body, and legs. If you start drawing from the face, the head is likely to become too large and the image won't be balanced. Start from the body and evenly progress through the face and legs to maintain the overall balance of the drawing. The direction of the fur changes according to the movement of the muscles and the folds of the flesh beneath. Draw along the direction of the lay of the fur, starting where the pattern of the fur stands out.

Completed drawing

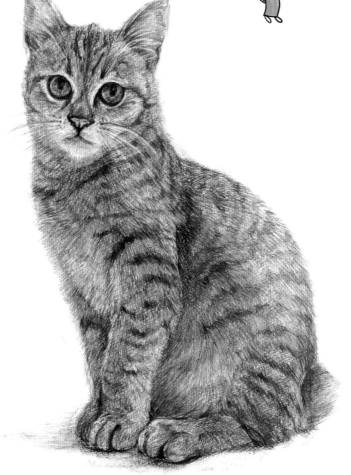

Check the structure

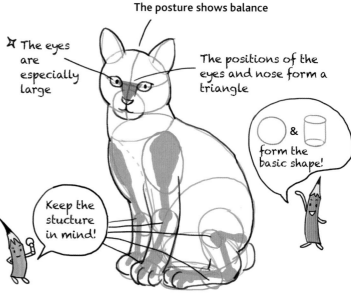

The posture shows balance

The eyes are especially large

The positions of the eyes and nose form a triangle

& form the basic shape!

Keep the stucture in mind!

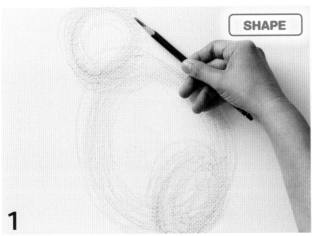

SHAPE

1

Sketch out the head, body and haunch. Use a soft B pencil to work on this step.

TIP To ensure that the head doesn't get too big, start drawing from the body.

2

Sketch out the shoulder of the foreleg.

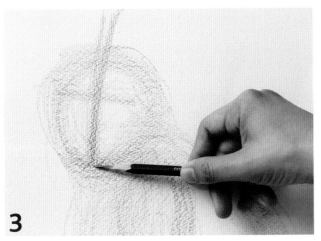

3

Draw the centerline of the face.

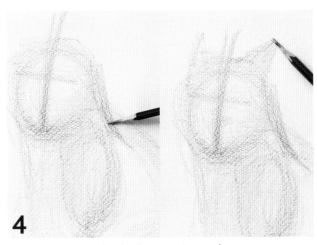

4

Start connecting the body parts. Draw the ears.

TIP The ears are quite large.

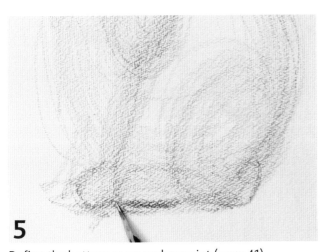

5

Define the bottom as an anchor point (page 41).

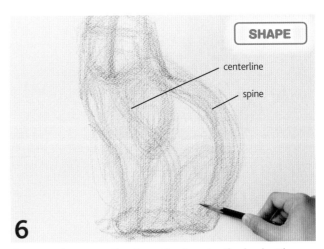

SHAPE

centerline

spine

6

Connect the centerline from the face to the body. Then outline the spine.

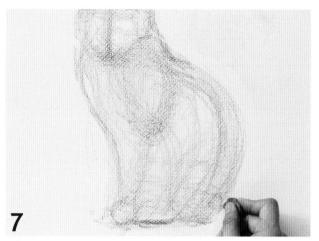

7

Adjust the outline with the eraser.

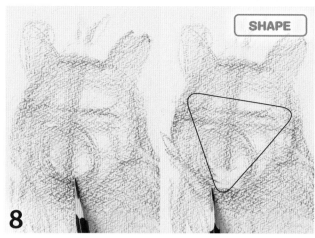

SHAPE

8

Outline the nose and mouth with a circle. Imagine an upside down triangle encompassing the chin and eyes while doing this.

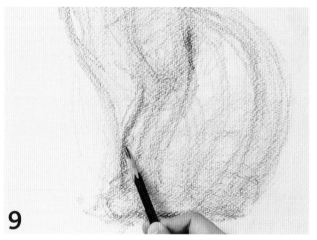

9

Mark the structure of the foreleg and define its shadows.

TIP Use the darkest areas as a guide, shading in those parts first. Keep in mind that the leg lines are actually not straight, but are quite elegant.

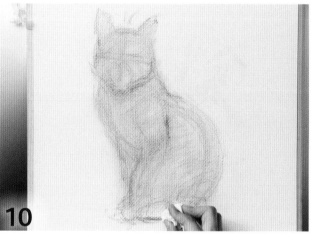

10

Use a tissue to blend in the sketch lines.

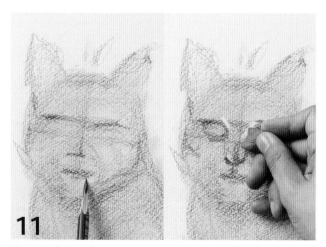

11

Start defining the eyes, nose and mouth. Use the eraser to help build contrast.

TIP Make sure the eyes, nose and mouth are parallel.

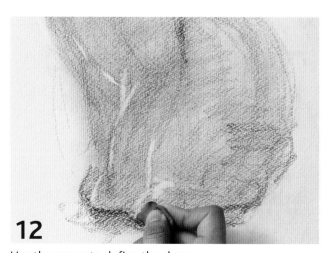

12

Use the eraser to define the shape.

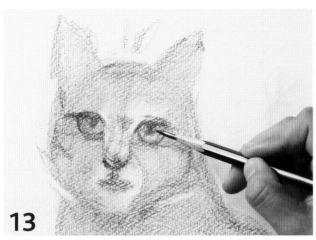

13

Hold the pencil in a detail grip to refine the face. Use an H pencil for this process.

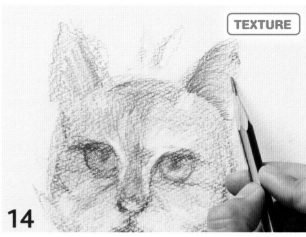

TEXTURE

14

Make strokes on the ear that coincide with the direction of the fur.

TIP Draw details with a sharp pencil.

TEXTURE

15

Define the details in the paws.

TIP If you focus exclusively on any one spot in particular, that spot will become unnaturally large. So keep moving around the drawing as you refine it.

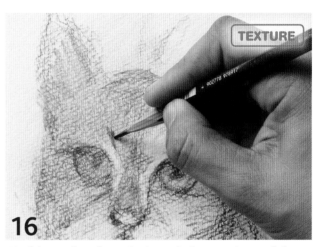

TEXTURE

16

Work in strokes along the brow, being cognizant of the way the fur changes with the underlying folds of the skin.

TIP Always keep your pencils sharp. This will enable you to place the fine lines that resemble hair.

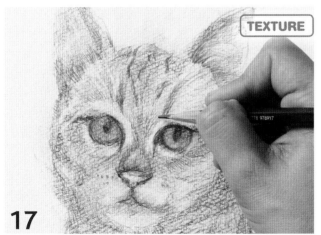

TEXTURE

17

Add the stripes and markings on the face and along the body.

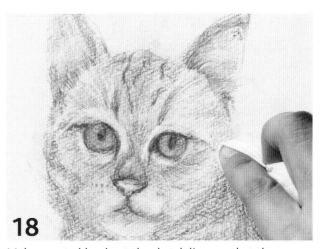

18

Make sure to blend out the sketch lines so that they are no longer visible.

TIP Apply a soft touch if you use an eraser in this step—it's easy to accidentally remove too much of the drawing.

Lesson 19

Parakeets

Avoid drawing birds with complicated patterns. Choose simple ones to start with.

Basics to apply (pages 26–35)

POSITION · SHAPE · TEXTURE

As with the cat (page 106), be aware that the bone structures of the head, body, wings and feet divide your drawing into different parts. You can make the task of composing the drawing easier by sketching out the feet first. Then, add patterns after adding general areas of contrast. Use the kneaded eraser to emulate the soft-textured look of the feathers.

Drawing notes

Draw out the base shape of each part and connect them

The position of the eyes and nostrils is important

Work on the patterns in groups

The toes are spread out

Completed drawing

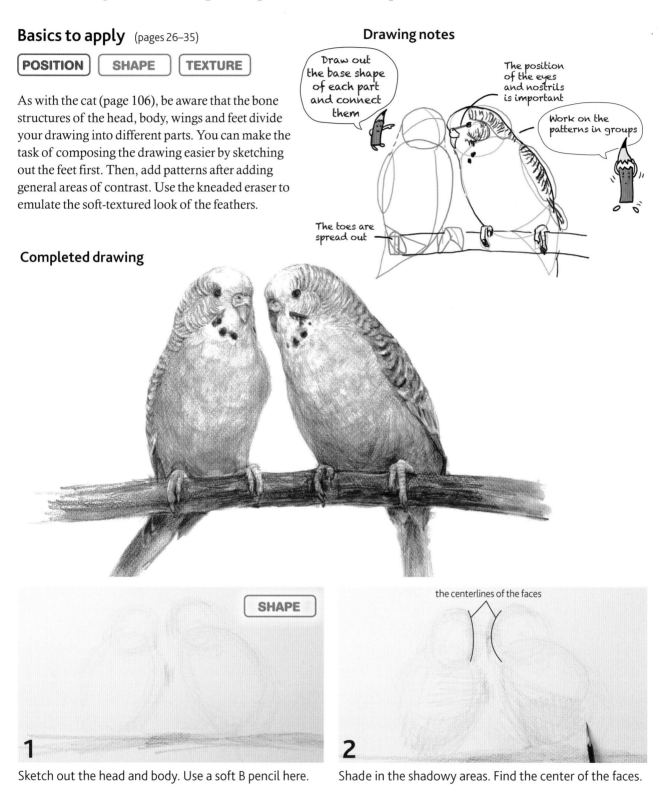

1 Sketch out the head and body. Use a soft B pencil here. Rough in the perch with broad strokes.

TIP Draw the body first, to ensure the head doesn't become too big.

2 Shade in the shadowy areas. Find the center of the faces.

the centerlines of the faces

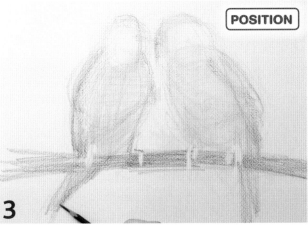

POSITION

3

Use the kneaded eraser to lighten areas for the toes. Define the wings.

TIP Observe how the toes spread to grip the perch.

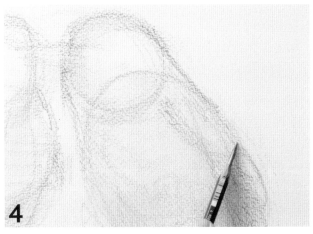

4

Connect the head and body.

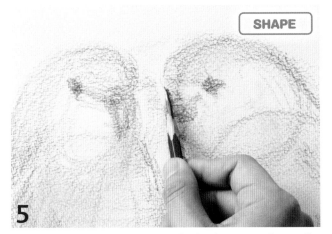

SHAPE

5

Use a soft B pencil to sketch in the beak, eyes and nostrils.

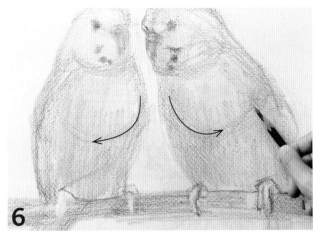

6

After adding in the pattern on the face, create shadows to show the swell of the chest.

TIP If you focus too much on the head, it will likely become too large. Work around the entire drawing instead.

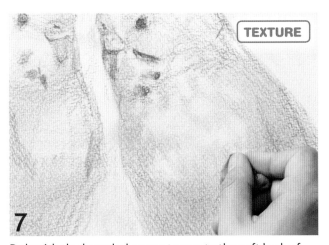

TEXTURE

7

Dab with the kneaded eraser to create the soft look of the feathers.

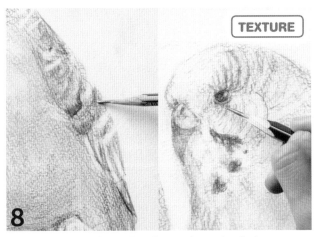

TEXTURE

8

Holding a B pencil in a detail grip, draw the darks pattern little by little. Use the kneaded eraser to heighten the contrast. Draw in patterns as you erase. Use HB and F pencils to add fine details around the head and eyes.

TIP Always keep your pencil well sharpened for drawing details.

Drawing Inspiration
Animals

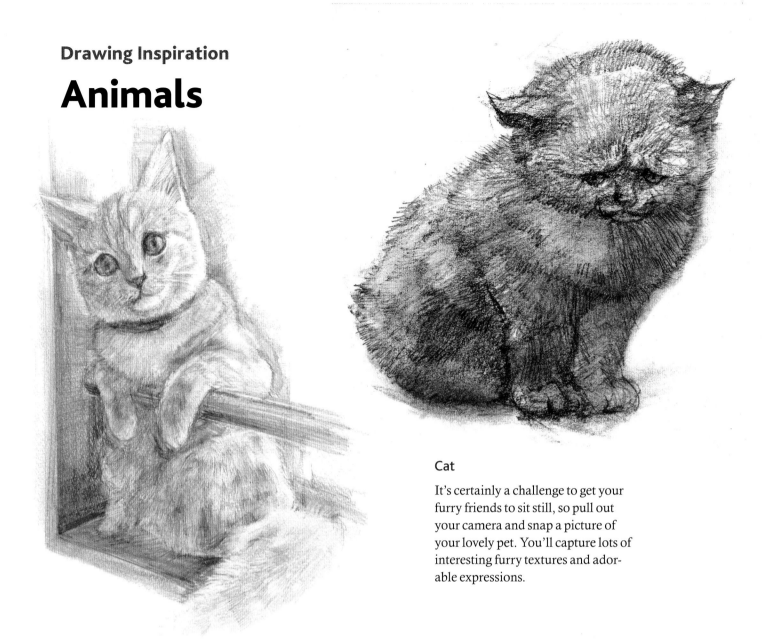

Cat

It's certainly a challenge to get your furry friends to sit still, so pull out your camera and snap a picture of your lovely pet. You'll capture lots of interesting furry textures and adorable expressions.

Seagull

One of the primary identifying characteristics of a seagull is the harsh look on it's face. Its structure almost makes it look as if it's grumpy all the time. Have some fun by adding color to your drawing. Staedtler colored pencils are excellent for this purpose.

Sparrow

Drawing birds is fun because it's satisfying to define the contrasting feather tones. Rely on your kneaded eraser to emphasize the contrast.

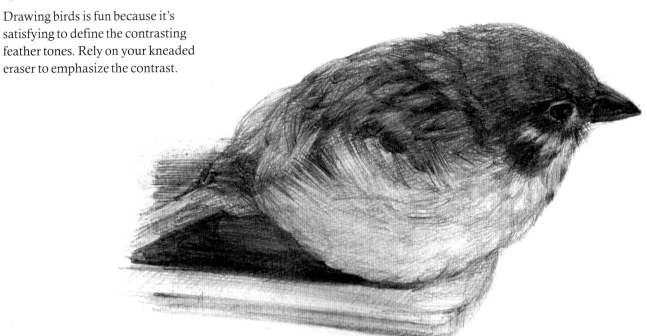

Dog

Pugs are especially fun to draw because they are naturally cartoon-like creatures. The wrinkles between the eyes and the nose, and the marble eyes are the most striking features. Use softer H or F pencils to capture the likeness.

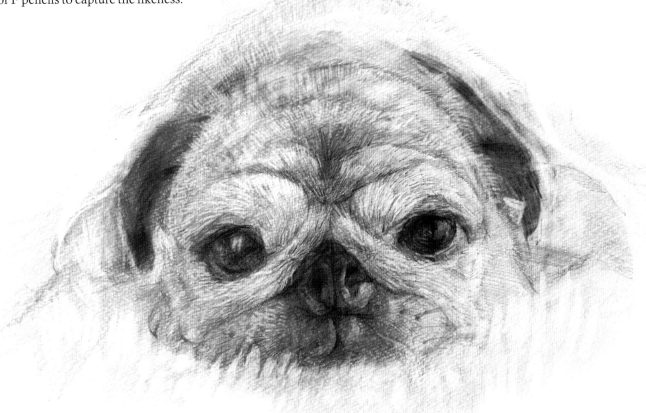

Warm up with Quick Sketching

To sketch is to draw quickly. You can warm up and get focused by starting with sketches.

Working quickly

Draw with only simple lines for a very short amount of time. Working like this has the side benefit of helping to focus your concentration. By making many quick sketches, you'll soon understand the form of your subject intimately, and begin to draw more quickly and accurately.

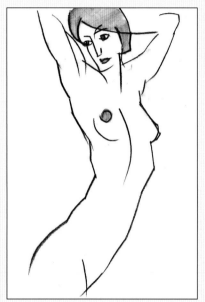

Use simple, quick lines

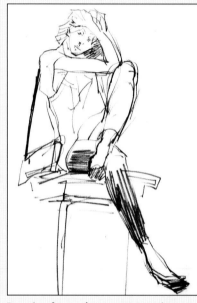

Drawing from a low vantage point

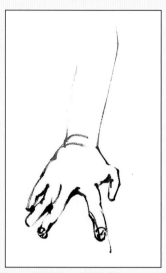

Fingers splayed out against a surface

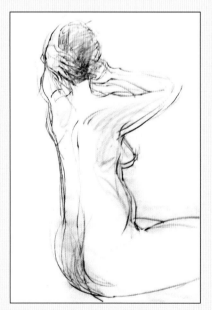

Using colors to express shapes

Sketch many angles and subjects for warm up practice

Invite a few people over for a sketching session

Meet with some friends for sketching session. Set up a 3-minute time limit for each sketch. After the session is over, you will likely feel tired. Intensive, sustained hand-eye coordination expends a considerable amount of mental energy. At first, drawing this way will feel unfamiliar, but with practice it will become second nature.

Sketching session tips

Participants should position themselves in a circle around the volunteer who it taking a turn as the model. Each time the model is replaced with a fresh volunteer, a different theme or pose should be adopted. Interesting themes could be: a fighting pose, waiting for a train, greeting a friend, etc.

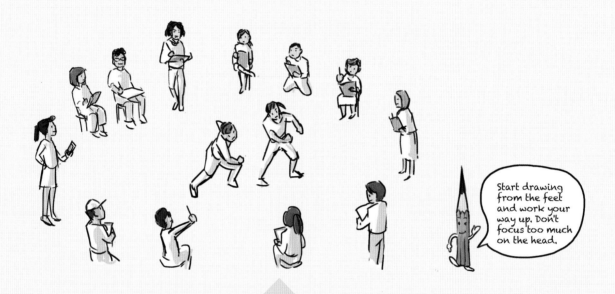

Start drawing from the feet and work your way up. Don't focus too much on the head.

TIP **Drawing challenges for the artists**

In addition to the changing poses of the models, suggest alternate starting points, varying vantage points and other challenges for the sketchers. For example, start drawing at the hands, draw from an elevated vantage point or draw the model without looking down at the paper (you will be surprised by the results of this last option—the lines will be smooth and loose).

Sketching alone

There's no reason that drawing cannot be a solitary activity. It's a lower pressure activity when done alone. You don't have to worry about preparing the tools you need, and you can use any pencils and paper you have handy. Without the concern of showing your sketches to anyone else, you can focus more on drawing. The more you sketch, the more accomplished you will become. Think of sketching as part of your drawing practice.

Lesson **20**
Color Contrast

Make your compositions interesting by combining objects with different shapes, textures and colors. The banana shown below is positioned to tie the image together, both by placing the object with the most mass lower on the paper, and by the way the curve of the fruit directs the eye back toward the tomatoes.

Basics to apply (pages 26–35)

| POSITION | | SHAPE |
| LIGHTING | | TEXTURE |

When combining objects with contrasting colors, use your gradation chart (page 20) and observe how deep each tone should be. The red of a deeply-colored tomato will be quite dark—nearly black. The yellow of the banana should not be completely white, even though it looks quite bright in comparison to the tomatoes. The banana is placed on the lower side to stabilize the composition.

Completed drawing

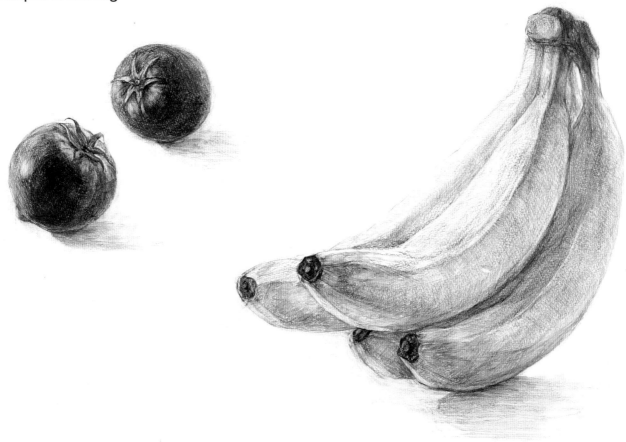

POSITION

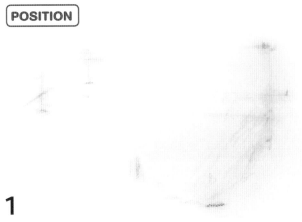

1

Mark the positions of each of the objects, and check the positional relationships. Measure and mark the ratio of the dimensions. Use a soft B pencil during this process.

TIP Position the banana at the bottom to stabilize the composition.

SHAPE

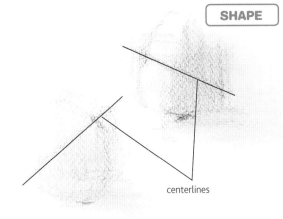

centerlines

2

Draw the centerlines of the tomatoes. Both are angled slightly and the bottoms of the tomatoes point downward. Define the shadows along the surface.

LIGHTING

Light

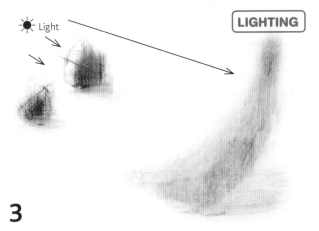

3

Add lots of shading to the dark tomatoes. Be mindful of the effects of the light source here.

4

Add shading to define the individual bananas, and darken the shadow beneath the cluster to anchor it into position (page 41).

SHAPE

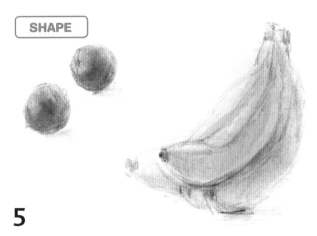

5

Banana are shaped as tapered and curved extruded pentagons, and tomatoes are nearly spherical hexagons. The shading is divided in accordance with the shape of the surface (page 38). Lighten the bright parts using the eraser.

TEXTURE

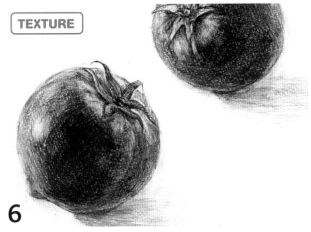

6

Heavily shade the darkest parts of the tomatoes (page 22). With a detail grip, use the pencil and eraser to work on the details. Continue to refine the drawing until you are satisfied with it.

Lesson 21
Different Textures

A bouquet of flowers makes for a good exercise to practice drawing contrasting colors and textures.

Basics to apply (pages 26–35)

POSITION TEXTURE SPACING

Distribute leaves and blossoms in a pleasing arrangement to give a sense of balance to the composition. The flowers should be large, and if you select those with varying colors, the image will have a vivid quality. The vase is basically cylindrical. Refer to the Mug and Glass lessons (pages 52 and 70). To add contrasting texture, lay a cloth under the vase. This will push you to use all your skills to emulate the texture and color of the gathered fabric. Use a wide range of pencils, from 3H to 8B.

Completed drawing

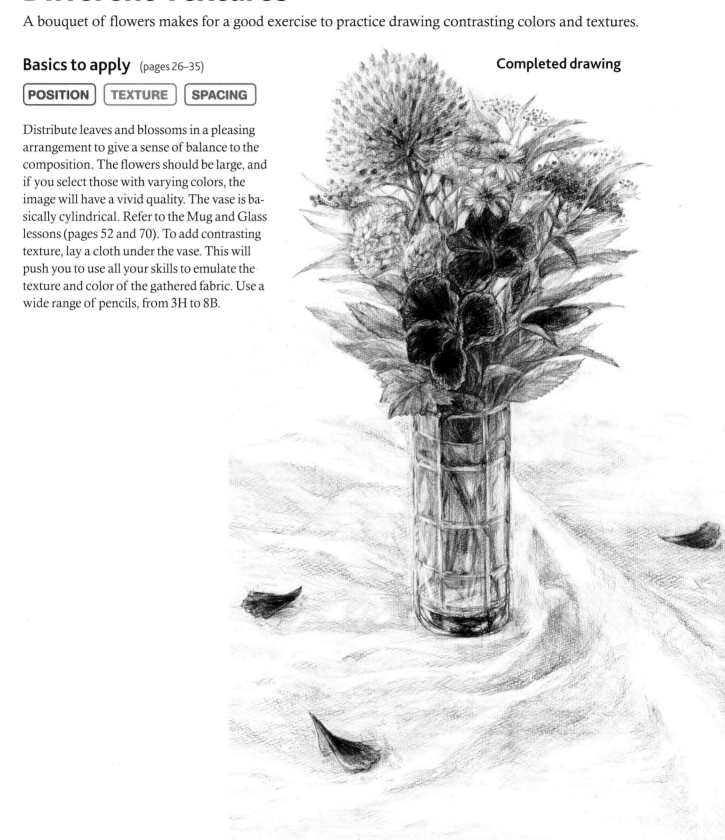

[POSITION]

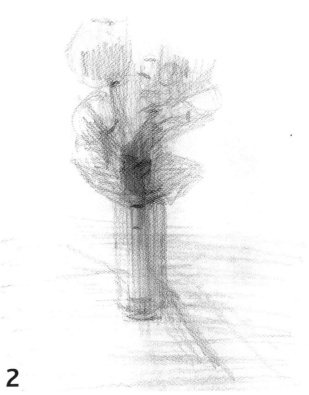

1

Mark the positions of each of the items with a soft B pencil, including the edges of the flowers and vase. Check the relationships of each of the points, and make sure that the base sketch is well proportioned.

2

Start to sketch out the flowers and vase by shading in the area, beginning to define the different areas of contrast.

[TIP] Use broad strokes as you work through this.

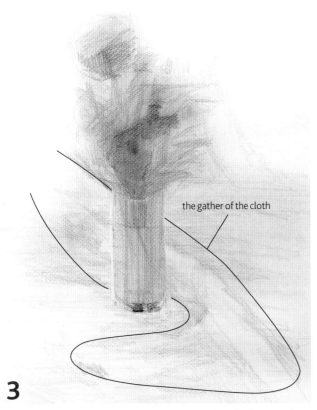

the gather of the cloth

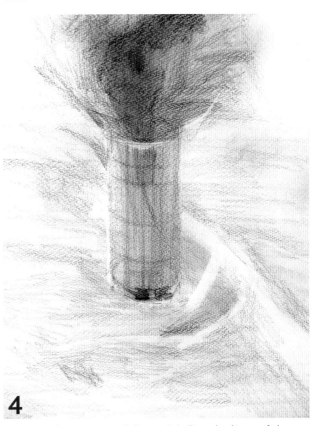

3

Observe the position of the creases of the cloth. Use the side of the eraser to mark the rise of the gathers, and use the pencil to define the shadows.

4

Measure the vase carefully, and define the lines of the vase. Refer to the basics of drawing cylinders (page 52). Add the highlight to the rim using the kneaded eraser.

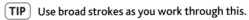

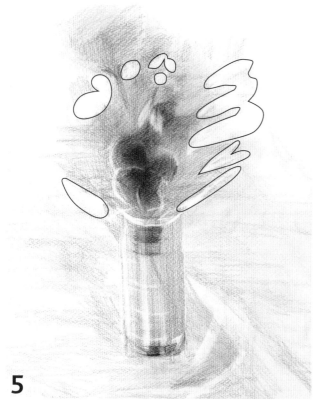

5

Use the kneaded eraser to differentiate between the edges of the bouquet and the empty space behind.

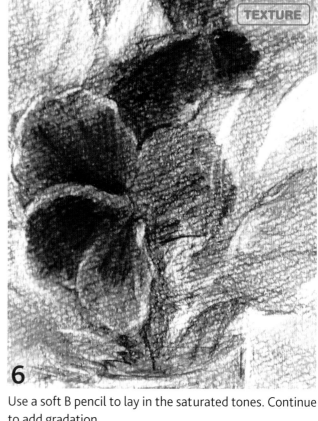

TEXTURE

6

Use a soft B pencil to lay in the saturated tones. Continue to add gradation.

(TIP) **The flowers become quite dark. Use an 8B pencil (if you have one) to work on these parts.**

SPACING

7

Use a soft B pencil for the front of the flowers. Blur the parts that are farther back to express depth. Add crisp lines to define the parts that should appear closer.

(TIP) **Use curving strokes to keep the texture looking natural.**

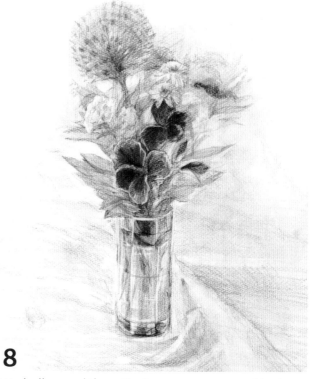

8

Work all around the entire image as you go, and try to not focus too much on any one point, to maintain the tonal balance. Work on the cloth with a soft B pencil. Use the eraser to create the highlights.

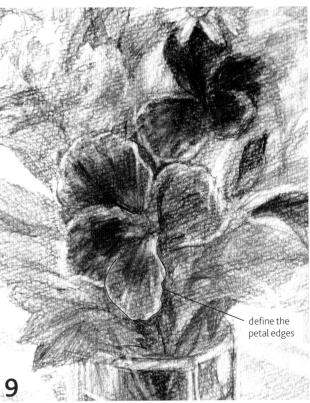

9

Add a crisp line to the edges of the bold flowers in the front (page 22). Use the B pencil to impart strong tones. Trace the curving edges of the petals to define them.

define the petal edges

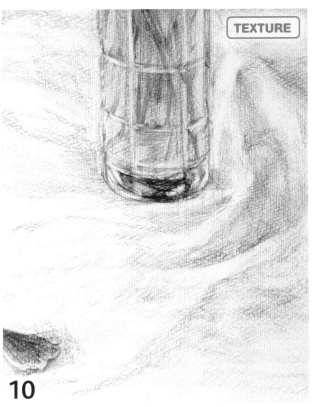

TEXTURE

10

Use a 2H pencil to develop the texture of the cloth, detailing the folds and raised areas.

TIP If you use a detail grip for this, the texture of the cloth backdrop will look distractingly crisp.

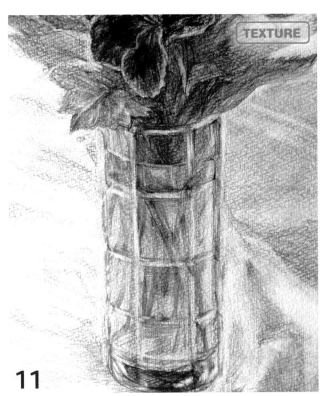

TEXTURE

11

Switch to a detail grip to develop the details of the vase. An H pencil is best for this work.

TIP Create enough contrast on the vase to emulate the shiny glass surface.

SPACING

12

The flowers in the back are subtly blurred. This lends a sense of depth. Use the eraser to tap bright spots into the image. Continue to adjust here and there until the drawing is completed.

Combining Objects

Fruits and Vegetables

Find some fruits or vegetables with different colors and textures to work on. Strive to bring out the quintessential characteristics of the produce. For an extra challenge, lay the items on a hardwood floor to add another element to your composition.

Pine Cone, Olive Oil, Cookies

There are interesting contrasting textures in these objects. The cookies are in transparent cellophane packaging. The olive oil bottle also has some transparency, although it is rigid. The pine cone scales resemble feathers or petals.

Wooden Container and Pears

The challenge in this example is to make the wooden container look like realistic wood that's been turned on a lathe. Study the texture of this object closely to emulate its characteristics.

Many Items All Together

With a composition like that in the example below, you have to decide how to position the different objects. There has to be a primary focus of the composition. In this case the focal point is the large sunflower. Consider the balance of the entire picture when placing the objects.

Inspirational Works

Here is a gallery of drawings and paintings I've made that incorporate the drawing techniques covered in this book. Drawing and sketching may be your passion, but don't let that stop you from venturing into mixed media artwork!

Humans

I enjoyed drawing models in a Paris studio. Seemingly no pose is unattractive when held by graceful dancers or acrobats, regardless of their experience as models! Important questions for the portrait artist are the following:

- How can I add the figure to my composition in an attractive way?
- Should I incorporate color into this piece, and if so, how?
- Will this be a rewarding artistic challenge for me?

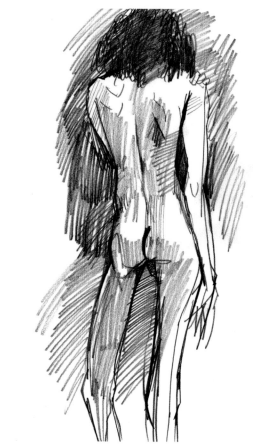

Croquis Man (pencil work; 290 x 210 mm)

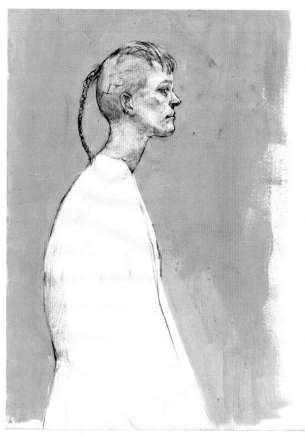

Hair Tied Up 1 (pencil work/acrylic; 290 x 210 mm)

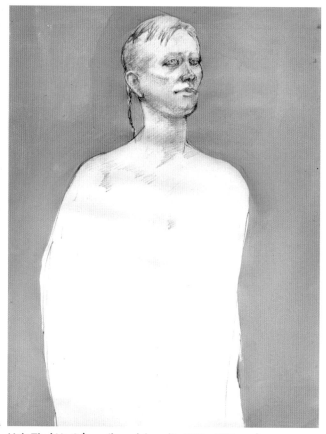

Hair Tied Up 3 (pencil work/acrylic; 290 x 210 mm)

9:58 AM (acrylic on canvas; 752 x 1016 mm)

Dreams

To warm up, I often draw images that came to me in my dreams. The landscape of dreams is strange and nostalgic. Drawing from memory and the imagination is a unique and gratifying challenge.

Heroes (acrylic on canvas; 333 x 410 mm)

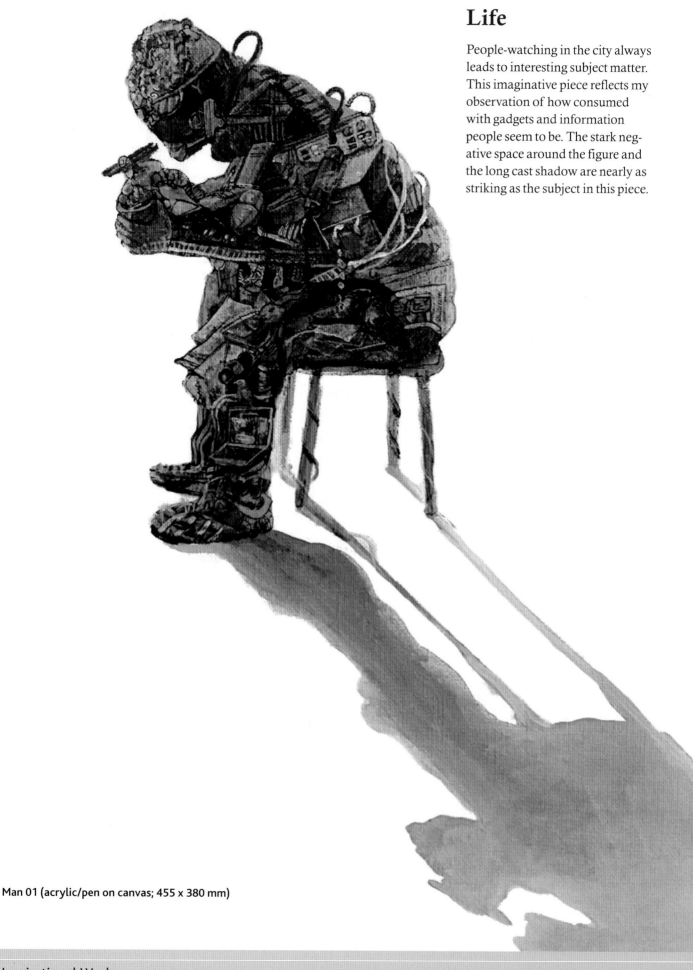

Life

People-watching in the city always leads to interesting subject matter. This imaginative piece reflects my observation of how consumed with gadgets and information people seem to be. The stark negative space around the figure and the long cast shadow are nearly as striking as the subject in this piece.

Man 01 (acrylic/pen on canvas; 455 x 380 mm)

Sketches of Horses (pencil and watercolor on paper; 290 × 210 mm)

Yellow Houses (pencil and watercolor on paper; 290 × 210 mm)

While Traveling

When you travel, keep a sketchbook handy along with the minimum necessary drawing materials. If you have free time, it's sketching time! I created this piece while staying in Corsica.

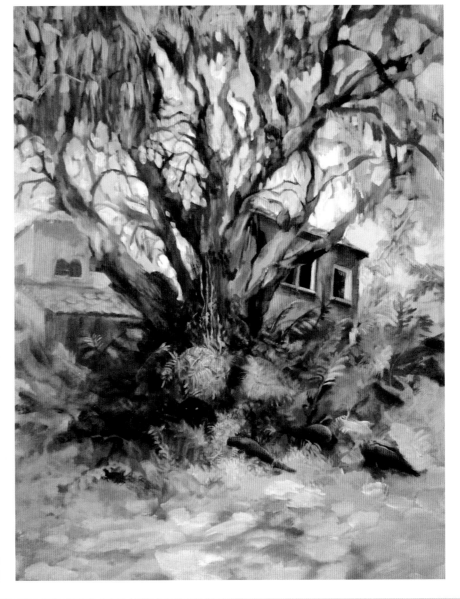

House in Corsica (acrylic on canvas; 909 × 727 mm)

Published by Tuttle Publishing, an imprint of Periplus Editions (HK) Ltd.

www.tuttlepublishing.com

ICHIBAN TEINEINA, KIHON NO DESSIN
Copyright © Yoshiko Ogura 2018
English translation rights arranged with
NIHONBUNGEISHA Co., Ltd through Japan UNI
Agency, Inc., Tokyo

English Translation © 2020 by Periplus Editions (HK) Ltd.
Translated from Japanese by HL Language Services

ISBN 978-4-8053-1576-7

Staff (original Japanese edition)
Editing and production Kana Goto (Lovita, Inc.)
Photography Amano Kenhito (Nippon Arts Co., Ltd.)
Bound/text design Maiko Shima
Illustration Yoshiko Ogura
Model Mayuko Inoue (Aire Co., Ltd.)
Calibration Hatsue Suzuki

Distributed by
North America, Latin America & Europe
Tuttle Publishing
364 Innovation Drive
North Clarendon,
VT 05759-9436 U.S.A.
Tel: (802) 773-8930
Fax: (802) 773-6993
info@tuttlepublishing.com
www.tuttlepublishing.com

Japan
Tuttle Publishing
Yaekari Building, 3rd Floor,
5-4-12 Osaki, Shinagawa-ku,
Tokyo 141 0032
Tel: (81) 3 5437-017
Fax: (81) 3 5437-0755
sales@tuttle.co.jp
www.tuttle.co.jp

Asia Pacific
Berkeley Books Pte Ltd
3 Kallang Sector #04-01
Singapore 349278
Tel: (65) 6741-2178
Fax: (65) 6741-2179
inquiries@periplus.com.sg
www.tuttlepublishing.com

25 24 23 22 21 8 7 6 5 4 3
Printed in Hong Kong 2104EP